IMAGES
of America

UNIVERSITY PARK
AND SOUTH DENVER

To Jean

Stan Dish

D1318408

ON THE COVER: The cornerstone laying for University Hall at the new University of Denver campus in South Denver is depicted on April 5, 1893.

IMAGES
of America

UNIVERSITY PARK
AND SOUTH DENVER

Steve Fisher

ARCADIA
PUBLISHING

Published by Arcadia Publishing
Charleston, South Carolina

Printed in the United States of America

Library of Congress Control Number: 2008941502

For all general information contact Arcadia Publishing at:
Telephone 843-853-2070
Fax 843-853-0044
E-mail sales@arcadiapublishing.com
For customer service and orders:
Toll-Free 1-888-313-2665

Visit us on the Internet at www.arcadiapublishing.com

For Katie

CONTENTS

ACKNOWLEDGMENTS

Thanks to Jim Kroll and Coi Drummond-Gehrig of the Western History Department of the Denver Public Library for the generous use of their images. Denver historian Phil Goodstein and Eileen Abbattista of the *Washington Park Profile* were also generous in sharing images with me. Many thanks go to the individuals who provided scanning and other technical assistance to me: Marcia Kehl, Ericca McCutheon, Dresha Schaden, and Thyria Wilson. Unless otherwise noted, the photographs are courtesy of the University of Denver Penrose Library, Special Collections.

INTRODUCTION

Clark Secrest, writing in *Colorado Heritage* magazine in 1992, pointed out that the short-lived town of South Denver had its own railway and its own university but almost no saloons. The town hall was located at 1520 South Grant Street in the former home of Mayor James Fleming, who served three terms.

The original boundaries of South Denver went from Colorado Boulevard to the east, the Platte River to the west, Yale Avenue to the south, and Alameda Avenue to the north. For the purposes of this book, the same boundaries have been kept with the exception of using a western boundary of Santa Fe instead of Pecos. South Denver formally existed for only eight years, from 1886 to 1894, but played a crucial role in the growth and development of the University of Denver and vice versa.

Colorado Seminary, as the University of Denver (or DU) was originally known, was founded in 1864 by John Evans and a group of prominent Denver citizens. Evans had previously founded Northwestern University in Chicago and wanted to create a college in Denver so future generations would not have to travel back east for higher education. Colorado Seminary occupied a single building at Fourteenth and Arapahoe Streets in Denver, approximately where the parking garage for the Denver Center for the Performing Arts now stands.

In 1880, the school added the name University of Denver as the degree-granting institution. It would own all the property, and the university would grant the degrees. By the 1880s, the Seminary Building was landlocked, making expansion difficult. Downtown Denver was also increasingly becoming home to a large number of saloons and brothels, just the type of institutions the good Methodist founders wanted to avoid. They wanted to create a utopian educational colony, a "university park." Evans already had some experience in this area, having helped develop Evanston, Illinois, the suburb of Chicago where his Northwestern University was located.

Deciding to vacate the downtown location for a more pastoral setting, the board of trustees in 1886 considered several offers of land, including parcels in Barnum's Addition and in the Swansea area. The offer that was accepted came from a group of farmers headed by Rufus "Potato" Clark, who promised 150 acres 3 miles southeast of the city limits in what was then Arapaho County. Clark had conditions to go with his offer, such as the planting of trees and the laying out of a street grid. He also demanded that no alcohol ever be made or sold in the area.

Clark was a reformed alcoholic who had been saved at a tent revival meeting. Today some home mortgages in South Denver still contain old covenants against producing or selling alcohol on the premises. In areas outside of Clark's original gift, the town of South Denver placed a $3,500 annual saloon license fee, high enough to keep out most of these types of establishments. Within a short time, other gifts of cash or outright gifts of neighboring land swelled the university's holdings to nearly 500 acres in the area.

Methodist bishop Henry White Warren and his wife, Elizabeth, demonstrated their support by purchasing land east of the university and in 1887 began construction on a home that came to be

known as Gray Gables. Clark's land offered a stunning view of 50 miles of front-range mountains away from the smoke and pollution of Denver. Charles Haines, an early resident, recalled in an interview when he was 102 years old that jackrabbits and coyotes outnumbered people for a number of years. Over the next few years, the university sold lots in the area to raise revenue.

In 1887, the Denver Circle Railroad extended a line into University Park. The next year, ground was broken in University Park for Chamberlin Observatory. Real estate promoter and amateur stargazer H. B. Chamberlin had given the funds to build the observatory. One advantage of building an observatory in University Park was the lack of urban lighting, which interferes with stargazing. Evans erected an office building at the corner of what is now Evans Avenue and South Milwaukee Street, which housed the first Methodist church in the area. The building still stands and is today an insurance office.

In 1890, ground was broken for University Hall, and in the fall of 1892, the school officially relocated to University Park. Church services would now be held in University Hall, which also housed all of the classrooms, administrative offices, the library, and the gymnasium. Though South Denver had several hundred residents by the mid-1890s, only a dozen or so residents were actually living in University Park. Despite these small numbers, the park already had telephone service, a post office, graded roads, and water from a well at Milwaukee Street and Warren Avenue. It was more than 10 years before electricity was installed throughout the community.

South Denver was still largely farmland, primarily growing alfalfa, corn, beets, apples, and cherries. The town of South Denver ceased to exist when voters approved annexation by the City of Denver, primarily for financial reasons. Though the residents of South Denver wanted to maintain their independence from the big city, the panic of 1893 had created a negative impact on real estate values. Taxes would be cheaper and more city services would be provided by annexation.

South Denver was not alone. Within 10 years, Denver had annexed Highlands, Barnum, Colfax, Globeville, Montclair, and Valverde. Today's South Denver is a vibrant part of the metropolitan area with beautiful homes and a tremendous variety of shopping and restaurants. Some things never change though. Liquor laws were relaxed after World War II, and it is now not so difficult to find a drink in South Denver, but neighbors still debate the granting of new liquor license applications. The trolley tracks were torn out in the 1940s, when buses became the norm. The transportation is being replaced again, this time by light rail.

Chamberlin's 20-inch refractor telescope is still the largest of its type in the Rocky Mountains region and still attracts scores of viewers to Observatory Park. Though much of the breathtaking view of the front range is now gone, portions of it can still be seen here and there from higher buildings on the DU campus and other areas such as Harvard Gulch Park and Prairie Park on Buchtel Trail.

One

The Birth
of South Denver
and University Park

The birth and growth of South Denver was closely linked to the growth of the University of Denver. In 1858, Montana City, just west across South Broadway Boulevard and south of Evans Avenue, was the first settlement near what would become Denver. It was short-lived, however, as the bulk of settlement moved toward Auraria.

When the University of Denver moved into South Denver in the last decade of the 19th century, the population of the area began to grow and services such as streetlights and water started to become available. Rail lines would soon link the suburb with Denver. The silver panic of 1893 made the annexation of the town of South Denver to Denver necessary. Steady growth continued up to the turn of the 20th century and beyond.

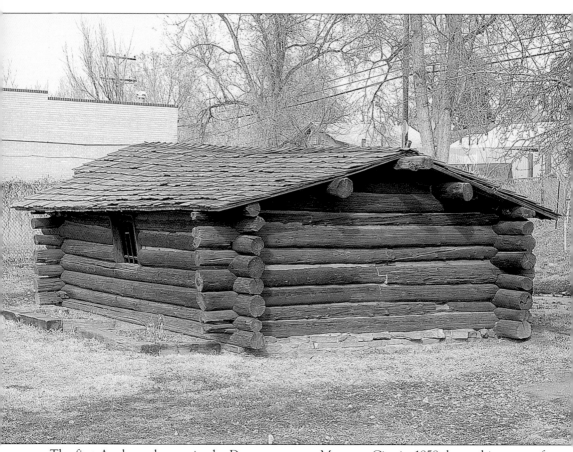

The first Anglo settlement in the Denver area was Montana City in 1858, located just east of the Platte River near Santa Fe Drive and Evans Avenue. An original Montana City cabin exists today in Grant-Frontier Park. (Photograph by Phil Goodstein.)

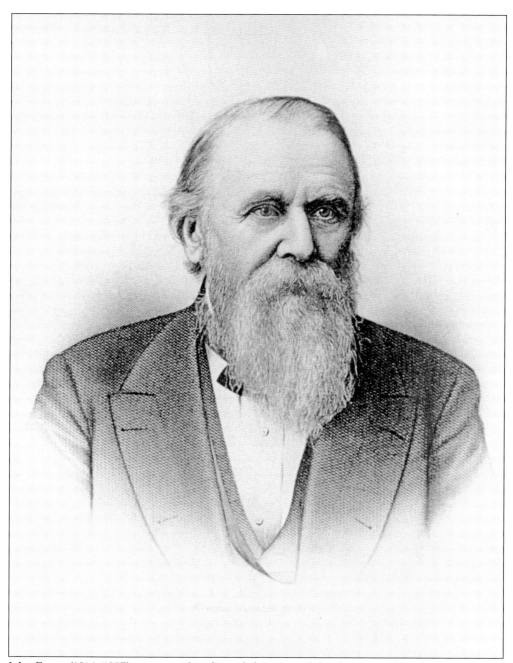

John Evans (1814–1897) was central to the early history and development of South Denver. Evans had already founded Northwestern University in Chicago (the suburb of Evanston is named for him) when Pres. Abraham Lincoln appointed him the second territorial governor of Colorado in 1862. Together with the Methodist Episcopal Church, Evans founded Colorado Seminary, later to become the University of Denver, in 1864. His goal was that the young men and women of Colorado Territory would not have to travel back east to attend college. In the 1880s, he helped organize the move of the University of Denver from downtown to the area known as South Denver.

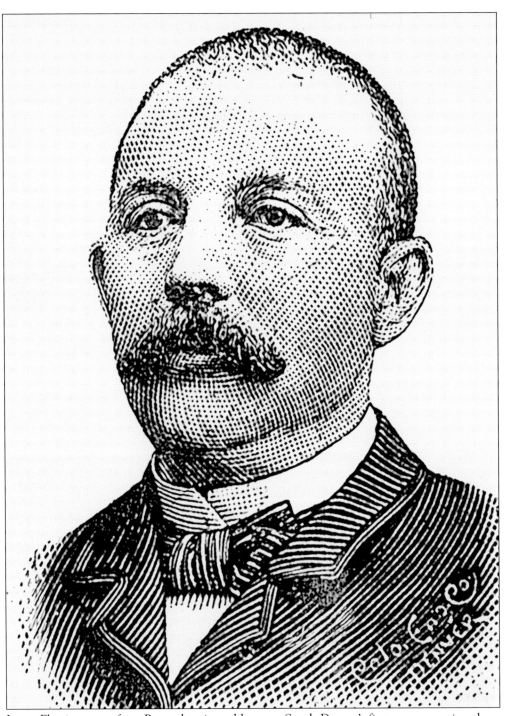

James Fleming came from Pennsylvania and became South Denver's first mayor, serving three terms from 1886 to 1890 before the town was annexed by Denver. (Courtesy Phil Goodstein.)

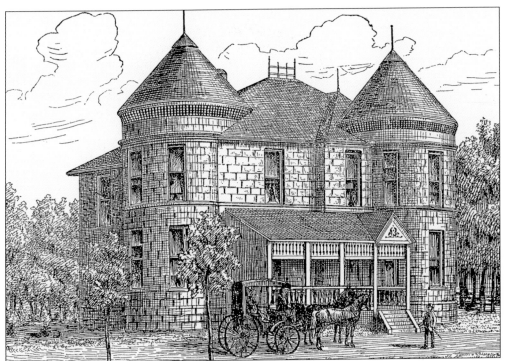

James Fleming built his estate in 1882 at South Grant Street and Florida Avenue. In 1891, he gave his home to the Town of South Denver. It was used over time as the library, jail, and town hall. (Courtesy Phil Goodstein.)

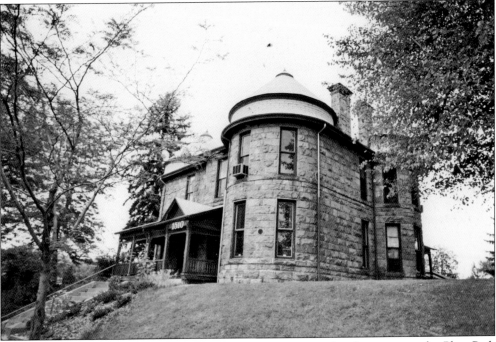

In 1956, the Fleming Mansion became a recreation center and today serves as the Platt Park Senior Center. (Courtesy the *Washington Park Profile*.)

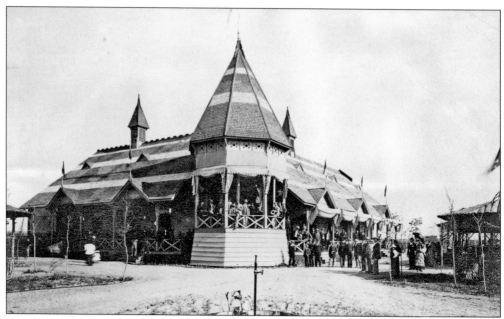

Sans Souci Concert Gardens was an elaborate beer garden located on the north side of Virginia Avenue between South Broadway Boulevard and Lincoln Street. It was constructed in 1882 by Baron Walter Von Richthofen. He ran into conflicts with the largely anti-saloon population of South Denver and sold the property in 1882. (Courtesy Denver Public Library, Western History Collection.)

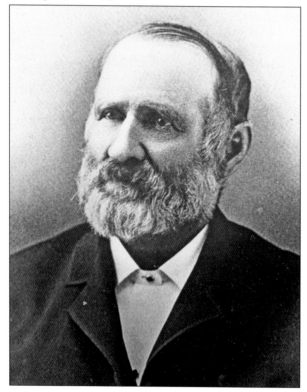

Called the "Colorado potato king," Rufus Clark was born in Connecticut in 1834. Making his way to Colorado in 1859, he filed a homestead on 160 acres of bottomland near the Platte River south of Denver. He made his fortune selling potatoes to the hungry miners who came looking for gold in Colorado, and in time his land holdings reached 20,000 acres. A heavy drinker, Clark found religion and swore off alcohol. In 1886, he gave the 80 acres to the University of Denver to allow their move from downtown Denver.

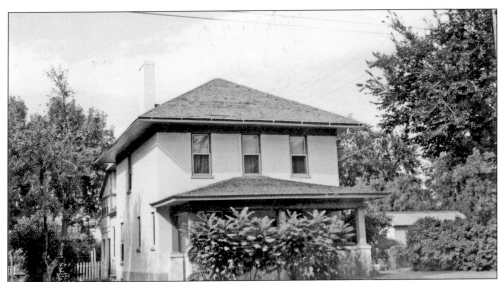

John L. Dyer (1812–1901) was a famous Methodist minister. His home at 2535 East Evans Avenue near South Columbine was the first single-family residence built in Observatory Park, existing as of at least 1886. After Dyer's wife died, his daughter Abbie and her husband, Charles Streeter, moved into the house and cared for Dyer. Dyer died in the home in 1901. (Courtesy Denver Public Library, Western History Collection.)

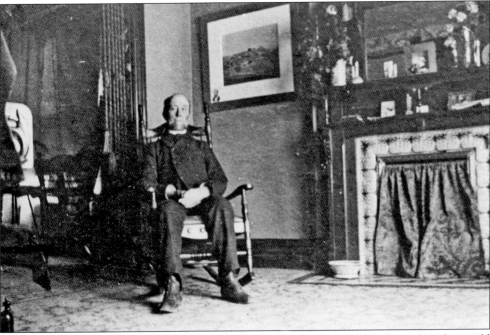

Many descriptions of famed Prof. Ammi Hyde mention his favorite rocking chair where he would spend hours. Born in New York in 1824, Hyde came to Colorado because of his wife's illness in 1880 to teach Greek and Latin at DU. He served as acting chancellor from 1889 to 1890 and in 1894 became the first pastor of the University Park United Methodist Church. Hyde retired in 1911 after 70 years of teaching but remained active in campus activities until his death in 1921 at the age of 97.

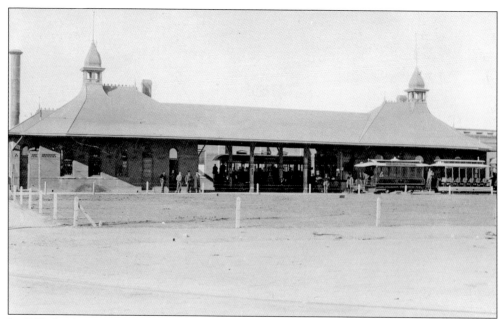

In 1889, the Denver Tramway Company began an extension of the Broadway Boulevard cable line through South Denver. Denver had the first electric streetcar line in the United States, begun in 1886. This photograph shows the South Broadway Tramway Station. One of the busiest lines in the city ran down Broadway to the suburb of Englewood. (Courtesy the *Washington Park Profile*.)

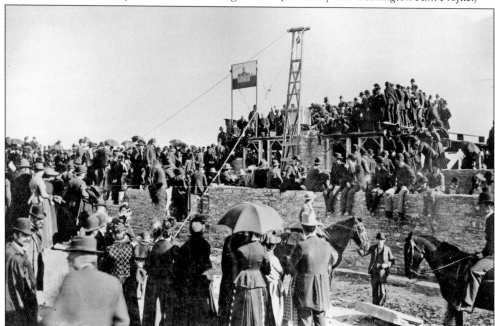

The University of Denver's first building at University Park was University Hall. It was designed by Robert Roeschlaub and built at a cost of $80,000. On April 3, 1890, special trains brought people to the site of the cornerstone laying, where a large crowd gathered for the occasion. Opened in 1892, "Old Main," as it is referred to today, is still in active use. The university spent over $3 million restoring the structure in the 1990s.

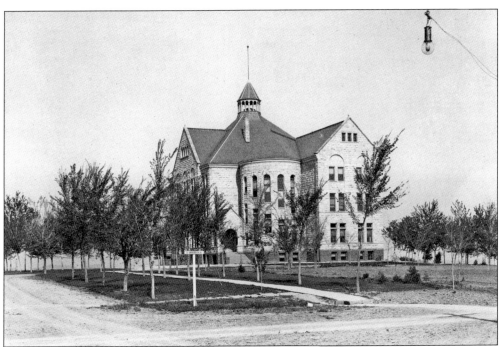

University Hall housed everything, including classrooms, administrative and faculty offices, the library, the chapel, and a gymnasium.

DU's Chamberlin Observatory is named for amateur astronomer Humphrey Chamberlin, who in 1888 gave the university funds to purchase a telescope and construct the observatory. Born in England in 1847, Chamberlin came to Colorado in 1880 in an attempt to improve his health. He became wealthy through real estate, water, and railroads. He later lost his fortune during the silver panic of 1893. He died in 1897.

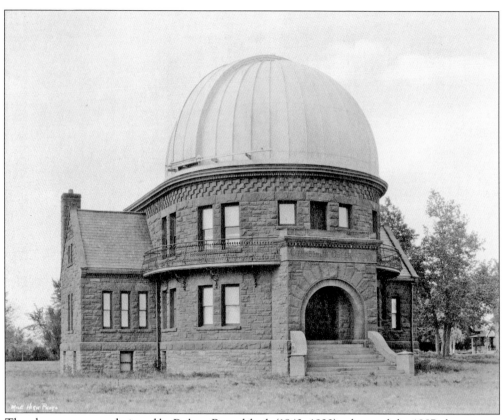

The observatory was designed by Robert Roeschlaub (1843–1923), who used the 1887 observatory at Carlton College in Minnesota as his model. The lens for the observatory telescope was brought from New York by train by DU astronomer Herbert Alonzo Howe.

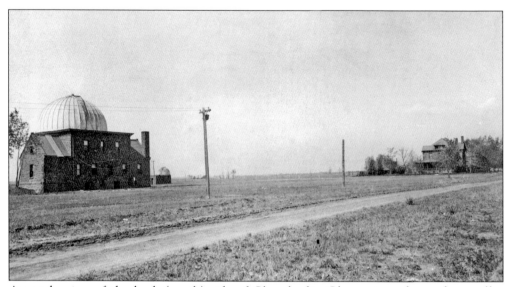

An early view of the back (north) side of Chamberlin Observatory shows the smaller student observatory. To the right is the Herbert Howe residence.

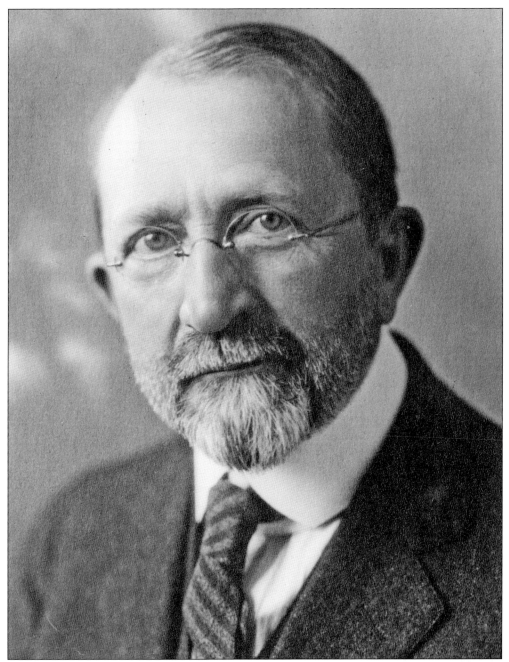

Best known as DU's first astronomer, Herbert Alonzo Howe was born in 1858 in New York. He came to Denver in 1880 with the new chancellor, David Hastings Moore. From 1888 to 1893, he oversaw the construction of the Chamberlin Observatory in University Park, which opened in 1894. Howe spent over 40 years at the university and became an internationally known astronomer. Howe died in 1926.

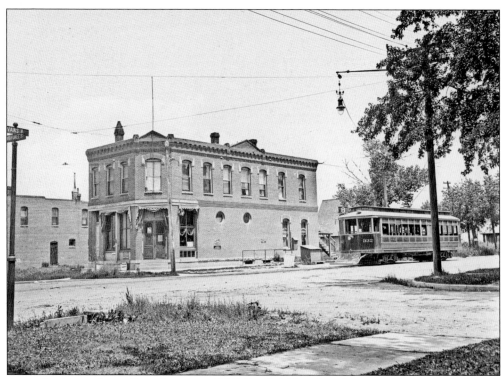

An early picture shows Evans's store at 2084 South Milwaukee Street in University Park with Tramway Company streetcar No. 332. This photograph was taken looking northeast across Evans Avenue. Constructed in 1888, the building is still standing. It housed the University Park Market from 1890 to 1968 and also held the first University Park Sunday school and first post office. (Courtesy Denver Public Library, Western History Collection.)

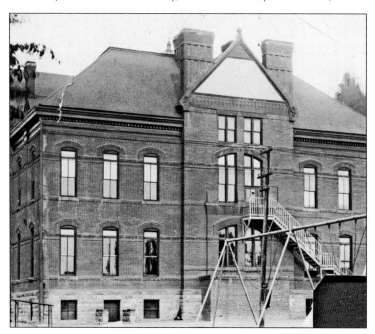

Lincoln School, located at 715 South Pearl Street near the corner of South Pearl and Exposition Avenue, was completed in 1891. After additions in 1904 and 1929, the original structure was demolished. (Courtesy Denver Public Library, Western History Collection.)

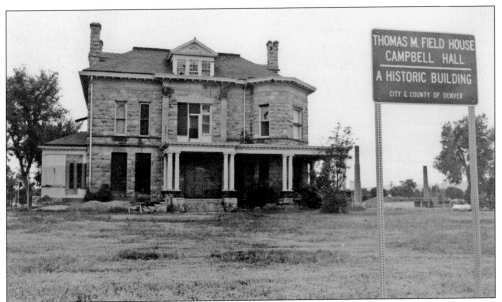

The Thomas Field House in Harvard Gulch Park is pictured here. Harvard Gulch Park is bordered by South Logan Street, Harvard Avenue, and Iliff Street. In the late 1800s, Thomas Field bought 40 acres that includes the park. Field was the treasurer of the City of Denver. The Fields built their home there in 1892. In 1901, the property was purchased by the State Home for Dependent and Neglected Children. In 1971, the home was closed. In 1978, the City of Denver acquired the property. (Courtesy the *Washington Park Profile*.)

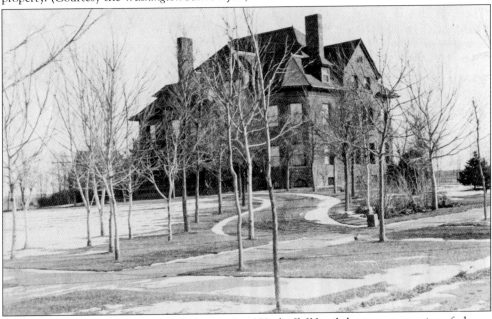

Fitzroy Place is also known as the Iliff mansion. In 1892, the Iliff family began construction of a home just east of Observatory Park on a block bordered by South Cook Street, South Madison Street, East Evans Avenue, and East Warren Avenue. It remained in the Iliff family until 1966, when John Wesley Iliff's daughter Louise Iliff sold it to Randell-Moore School, the current owner. The home was named to the National Register of Historic Places in 1975 and made a Denver landmark in 2007.

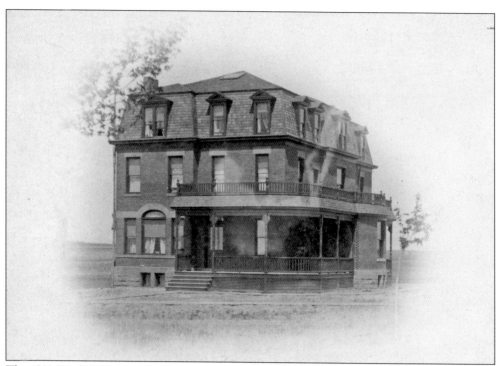

The 1892 Wycliffe Cottage for Girls was an early residence for female DU students. It was located at Asbury Avenue and Columbine Street. It later became home to the Phi Kappa Sigma fraternity and then served as a boys' school.

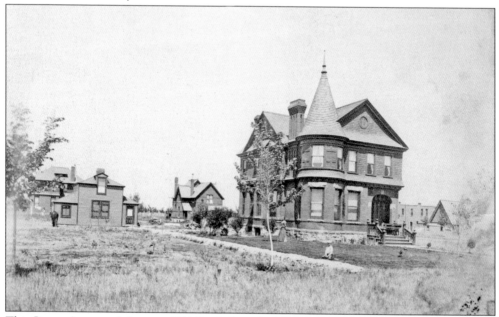

This Queen Anne–style home at 2111 South Saint Paul Street was constructed in 1890 by Frederick A. Walter, a contractor who was also the first occupant. It was later occupied by geography professor Wilbur Engle of DU and his wife, Emma. Engle served as acting chancellor of the university from 1920 to 1922. He passed away in 1952. This photograph was taken around 1893.

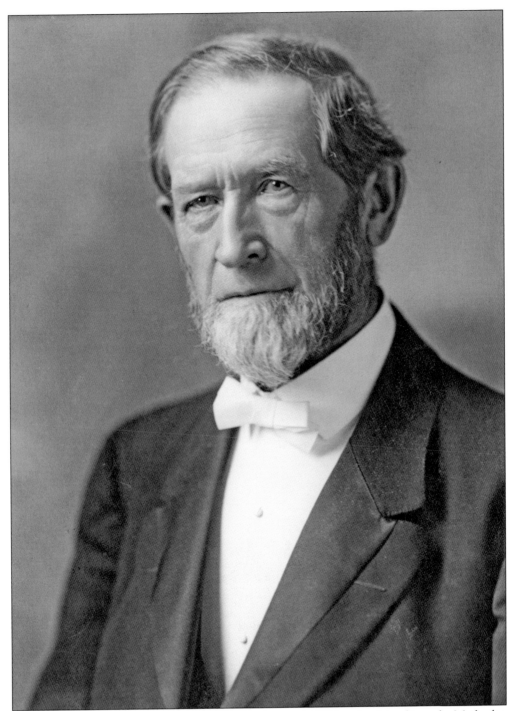

Bishop Henry White Warren was born in Massachusetts in 1831 and ordained into the Methodist Church in 1855. He came to Colorado in 1879 where he met Elizabeth Iliff, widow of cattle baron John Wesley Iliff (1831–1878). Iliff had been the most successful cattle rancher in the territory. Warren was a widower himself, and he and Elizabeth married in 1883. By this time, he was a bishop. Together they helped found the Iliff School of Theology in 1892.

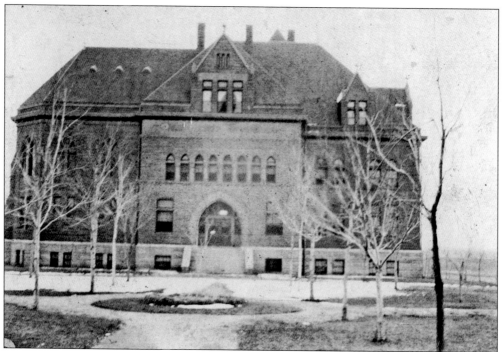

The Iliff School of Theology Building was constructed in 1892 to house the university's theological school with a $100,000 contribution from Elizabeth Iliff Warren, wife of Bishop Warren. It was built in the Richardsonian Romanesque style by Fuller and Wheeler, a New York architectural firm. The Iliff School of Theology later closed in 1897 and reopened in 1910 as a separate entity from DU.

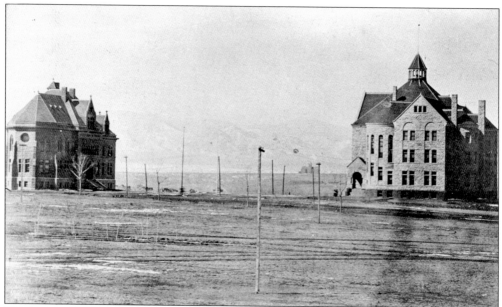

The view of the front range from the circle between the Iliff School of Theology and DU's University Hall was breathtaking in the 1890s. In the far distance, the newly opened Loretto Heights Academy building is visible.

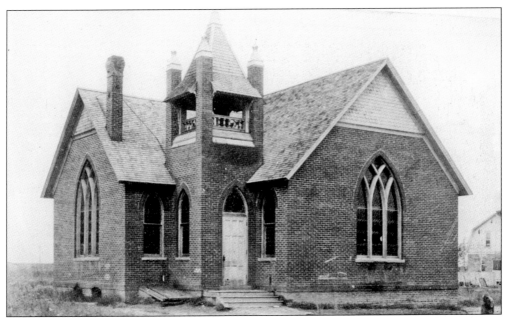

Here is an early photograph of the Myrtle Hill Methodist Church. The Myrtle Hill subdivision was an area east of Washington Park. The original Myrtle Hill congregation met in a home at 725 South High Street until this structure was completed in 1893 at South High Street and Tennessee Avenue. The congregation changed the name of the church to the Washington Park Methodist Church in 1911. (Courtesy John Alton Templin.)

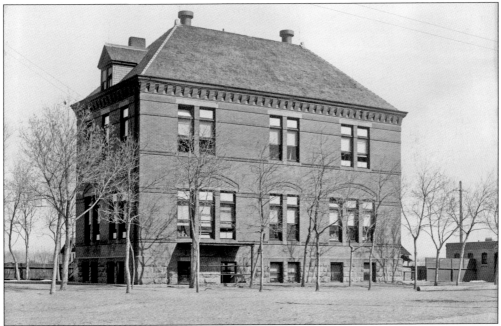

The original University Park School was built in 1893 at 2300 South Saint Paul Street at the corner of Iliff Avenue and Saint Paul Street. It was at that time a part of the Arapahoe County School District. The original structure was later demolished. After several additions, the current school building was constructed in 1950. (Courtesy Denver Public Library, Western History Collection.)

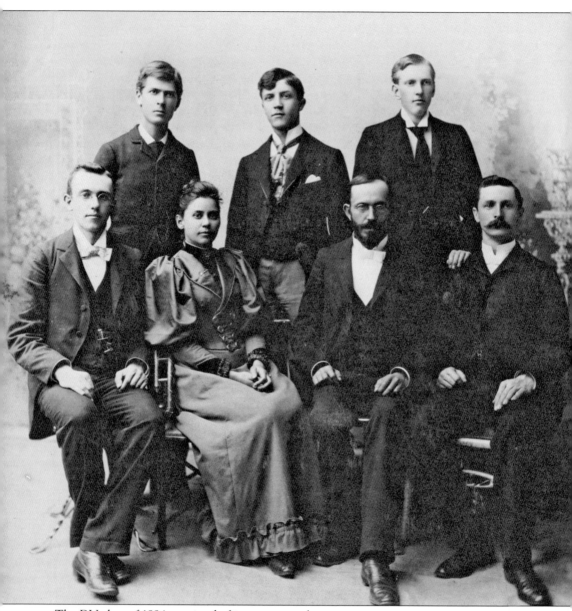

The DU class of 1894 consisted of just seven graduates.

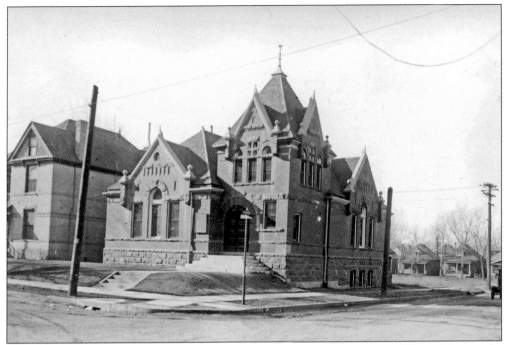

The First Reformed Presbyterian Church was dedicated in 1893 at 501 South Pearl Street, the corner of South Pearl and East Virginia Streets. (Courtesy Denver Public Library, Western History Collection.)

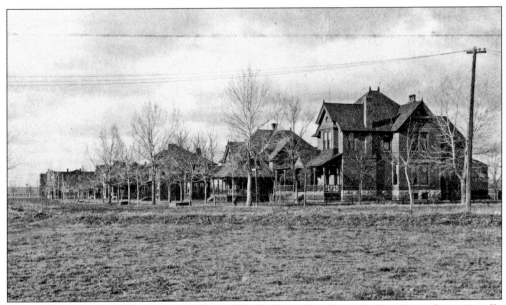

The young University of Denver was able to offer faculty reduced rates for housing and occasionally free rent. In the late 19th and early 20th centuries, a "Professors' Row" grew along the 2100 block of South Milwaukee Street in the park.

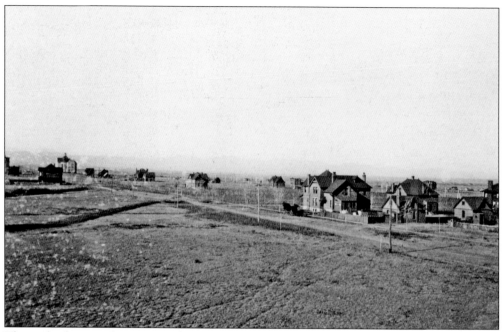

This early photograph captures a distant view of the DU campus looking west from the east side of University Park. The tallest structure in the distance is the brand-new University Hall.

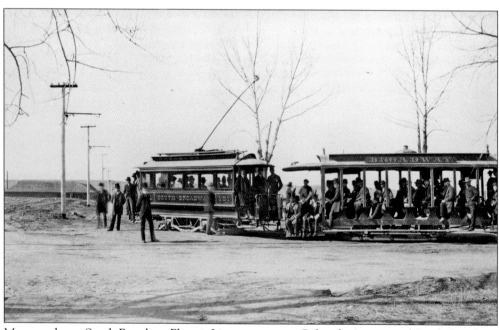

Men stand near South Broadway Electric Line streetcars at Colorado Avenue and South Broadway Boulevard. These cars were part of the University Park Railway and Electric Company. Both open-air cars and closed cars are visible. (Courtesy Denver Public Library, Western History Collection.)

This early photograph of Platt Park was taken around 1895. Though often confused with the Platte River, Platt Park was in fact named after James Platt, founder of the Platt Paper Company. It was given the name by the Board of Park Commissioners in 1895 for the area surrounding the Thomas Fleming estate, which is visible in the background of this photograph. Platt Park neighborhood boundaries are roughly from South Downing Street to South Broadway Boulevard and Mississippi Avenue to Evans Avenue. (Courtesy *Municipal Facts.*)

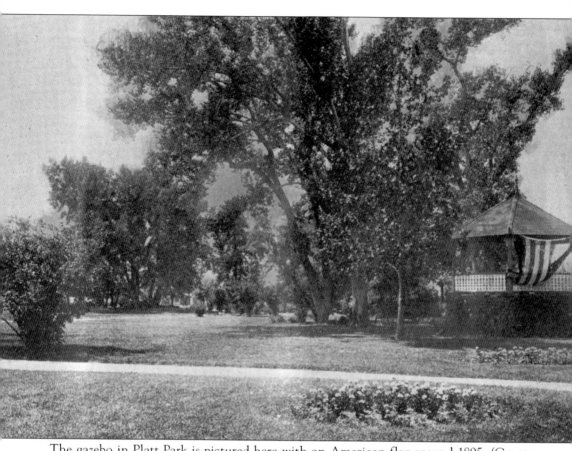

The gazebo in Platt Park is pictured here with an American flag around 1895. (Courtesy *Municipal Facts.*)

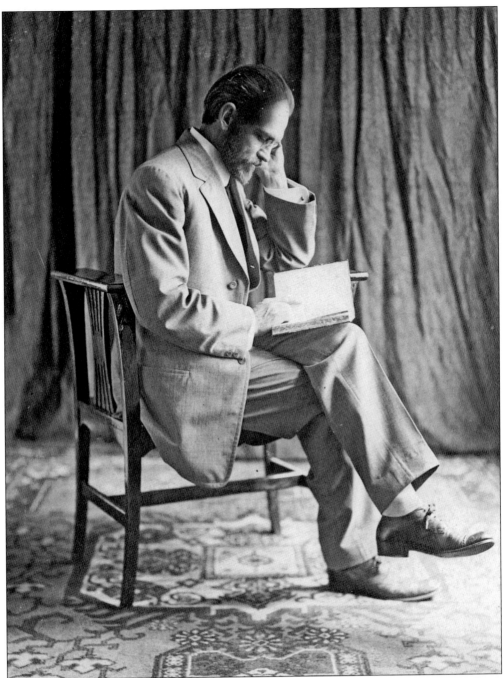

Ira Cutler was a professor of biology and zoology at DU from 1898 until his retirement as professor emeritus in 1934. Cutler was a man of boundless energy and varied interests. He was famous for propagating the DU rose (*Rosa Denver*), which blooms in DU's colors of red and gold. During World War I, he administered the DU Reserve Officers' Training Corps (ROTC). He also helped organize the first Boy Scout troop west of the Mississippi. Cutler enjoyed music, organizing the DU Glee Club, and directing the choir at the University Park Methodist Church. He was also a well-known ornithologist. Cutler died in 1936.

Marjorie Cutler, daughter of Prof. Ira Cutler, served as registrar of the University of Denver for over 30 years.

Two

THE BUCHTEL YEARS

Henry Augustus Buchtel, the former pastor of Trinity Methodist Church, was known as a master fund-raiser, and the University of Denver turned to him in 1900 to lead it through hard times. For the next 20 years, he succeeded far beyond anyone's expectations. An old joke that circulated for many years spoke to his talents for raising funds. It told of a young boy who had swallowed a nickel. "Go get Chancellor Buchtel," someone suggested. "If he can't get the nickel out of him nobody can!" Buchtel was so well respected that he ran for governor of the state of Colorado and won, serving from 1907 to 1909. Buildings sprung up rapidly on the DU campus during his tenure—a gymnasium, the Science Hall, a library, and a chapel. South Denver survived the great blizzard of 1913 and World War I. The DU campus housed an active ROTC chapter, and a number of current students and alumni served in the Great War.

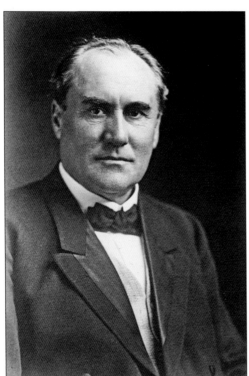

Chancellor Henry Augustus Buchtel (1847–1924) is credited with saving the University of Denver from bankruptcy. A Methodist minister, Buchtel served as chancellor of the university from 1900 to 1924 and also served one term as Colorado's governor from 1907 to 1909 while remaining DU chancellor.

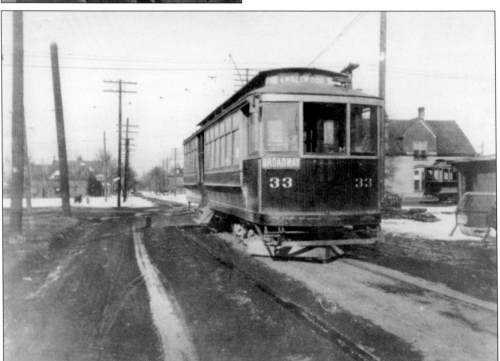

When the trolley car lines expanded into South Denver down Pearl Street from Alameda Avenue to Evans Avenue and east to DU, it greatly aided in the expansion of the area. (Courtesy the *Washington Park Profile*.)

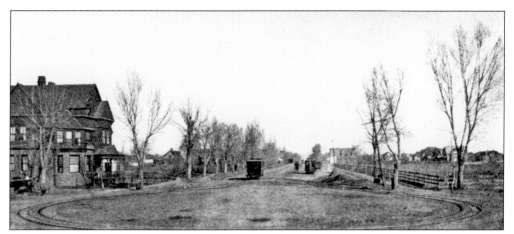

John Evans incorporated the Denver Tramway Company in 1886, and in 1899 several competing companies merged with it to form what would become the Denver Tramway Corporation. This company ran streetcars until 1950, when all of the lines were finally converted to bus lines. (Courtesy the *Washington Park Profile*.)

In this photograph, taken around 1900 of University Park looking west toward the front range, a number of recently constructed private homes are visible.

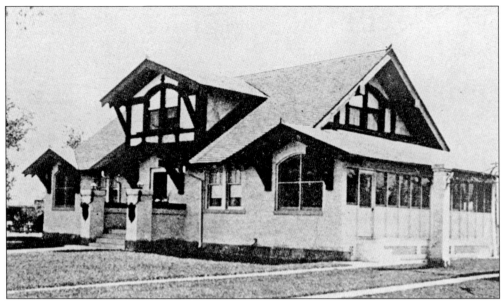

The University of Denver built this house as a residence for Chancellor Henry Buchtel, who lived here from 1906 until his death in 1924. It was designed by Harlan Thomas and located at 2100 South Columbine Street, the corner of East Evans Avenue and South Columbine Street. It was one of the earliest Denver bungalows. During his tenure as governor of Colorado from 1907 to 1909, Buchtel kept the house as his residence. The university purchased the bungalow from Buchtel's widow, Mary, in the 1930s. Able to hold up to 150 people, in later years the "Buchtel bungalow" has been used by the university for small social events and meetings.

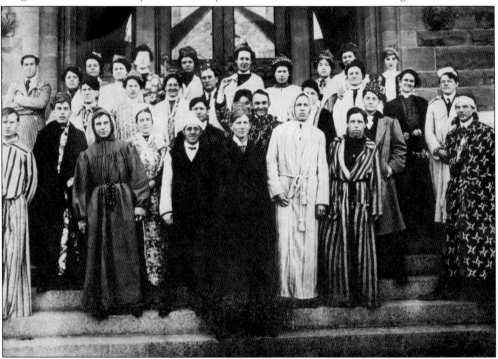

DU students pose in their nightclothes in this 1906 gag photograph.

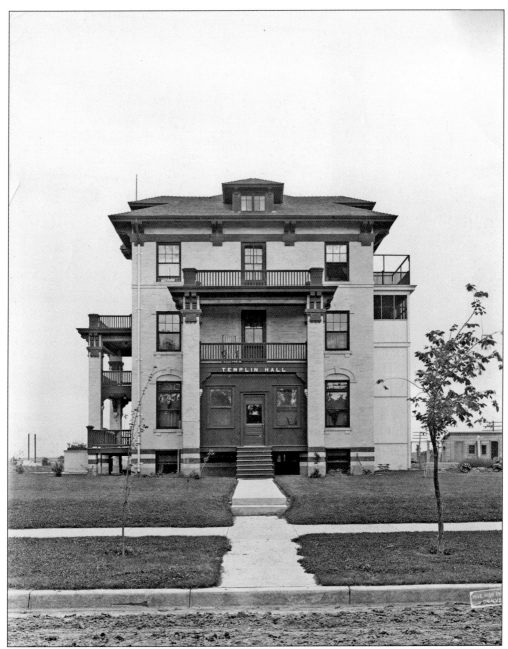

Templin Hall was constructed at Evans Avenue and South Josephine Street in 1907 as a residence hall for female DU students. It was financed by Charles Templin, who was a DU student. It was later sold to the university. In subsequent years, it housed the School of Social Work, the National Opinion Research Center, and an English laboratory for foreign students. The structure was demolished in 1979.

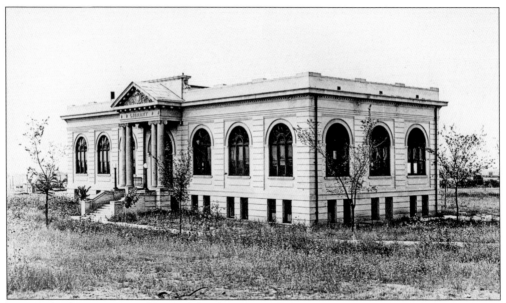

In 1907, funding was secured from philanthropist Andrew Carnegie, founder of the Carnegie Steel Company, to build the first separate library on the DU campus. The Carnegie Library opened in 1908. In total, Carnegie funded construction of over 3,000 libraries in his lifetime, but unlike DU's, most of them were public libraries. DU's library was the last one personally funded by Carnegie. After the construction of the Mary Reed Library in 1930, the Carnegie served many uses, such as the student union and the campus bookstore. It was demolished in 1990.

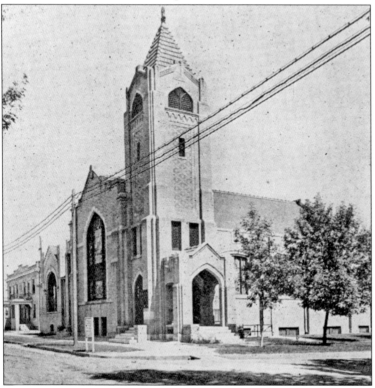

This is a 1908 photograph of the Grant Avenue Methodist Episcopal Church. The first church at this site was constructed in 1892 near the site of the present church at South Grant Street and East Cedar Avenue. It was enlarged in 1899 and again in the 1920s. It was recently designated a Colorado Historic Landmark. Today it houses the Grant Avenue Community Center and Sacred Place, Inc. (Courtesy *Municipal Facts*.)

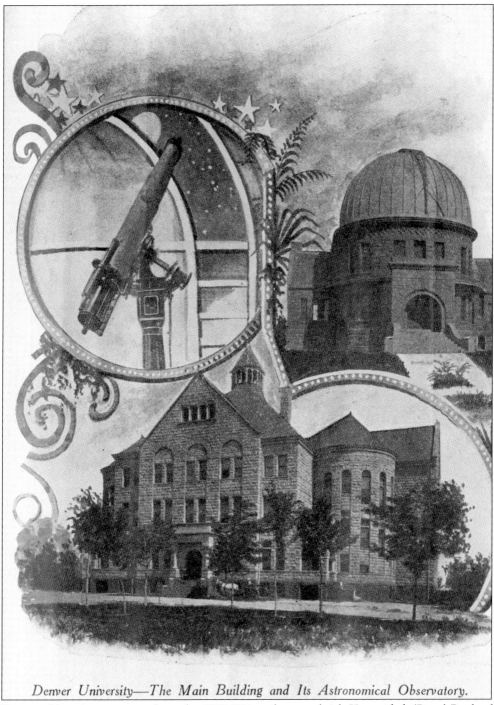

Denver University—The Main Building and Its Astronomical Observatory.

Presented here is a montage from the 1909 DU student yearbook *Kynewisbok* (Royal Book of Knowledge) of University Hall and the Chamberlin Observatory.

This home at 2102 South Milwaukee Street was built around 1890 and was for many years the home of well-known DU professor Ammi Bradford Hyde. Local residents have always described it simply as the "Hyde House." Hyde served many roles at DU, including professor of Greek and Latin, university chaplain, and acting chancellor from 1889 to 1890.

A 1910 photograph shows DU football fans at Broadway Park. This field was located at Sixth Avenue and Broadway Boulevard. The first large baseball stadium in Denver was also located here. Shortly after this photograph was taken, DU began playing football much closer to campus, at a field north of Evans Avenue between South Clayton and South Fillmore Streets in the area that would later become Buchtel Boulevard.

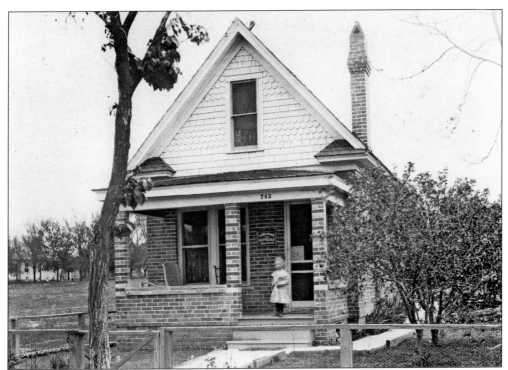

In this 1910 photograph, Frances Marie Kober stands on the porch of her home at 742 South Emerson Street in West Washington Park. (Courtesy Denver Public Library, Western History Collection.)

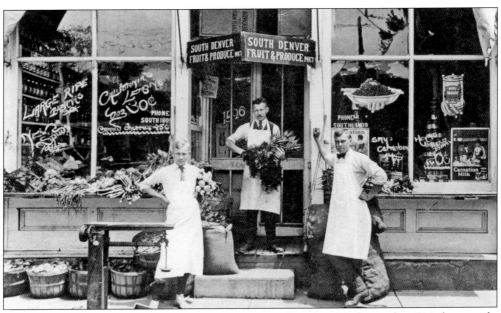

Grocers stand in the front of the South Denver Fruit and Produce Market in this 1910 photograph. The market was located at 1526 South Pearl Street. Today the site is a parking lot in the popular Pearl Street shopping area. (Courtesy the *Washington Park Profile*.)

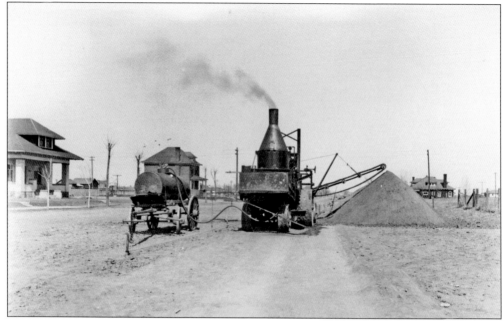

In 1894, the Denver Union Water Company was formed out of several smaller competing companies. By 1906, Denver water was being chlorinated. This 1910 photograph shows water pipes being installed in South Denver. (Courtesy *Washington Park Profile*.)

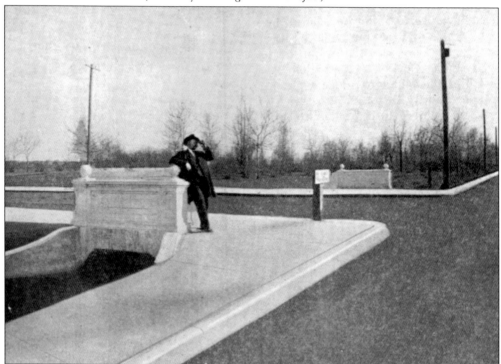

Formerly known as Smith's Ditch, the City of Denver purchased the line for $60,000 in 1875 and renamed it City Ditch. This 1911 photograph shows a bridge over the City Ditch near Washington Park. (Courtesy *Municipal Facts*.)

This 1911 photograph shows the Ferndale Dairy, which was located near the intersection of Colorado Boulevard and Alameda Avenue. At this time, Colorado Boulevard was known as McKinley Avenue in honor of the assassinated president. (Courtesy *Municipal Facts.*)

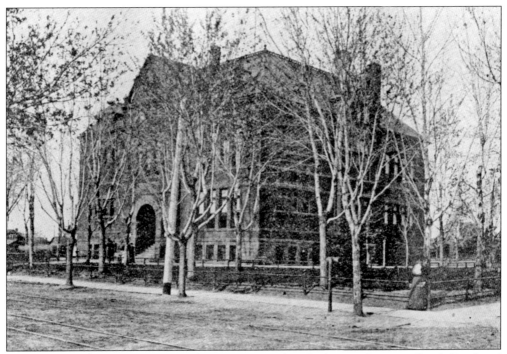

The original Grant School was built in 1890 at Colorado Avenue between South Pearl and Washington Streets. An elementary school at first, it was used as a high school beginning in 1893. This photograph was taken in 1911 and shows an addition from 1907, shortly after it became known as South Side High School. It remained the high school until the current Denver South was constructed in 1926. It then became a junior high school. The original structure was torn down in 1953 when the present Grant Middle School was built. (Courtesy *Municipal Facts.*)

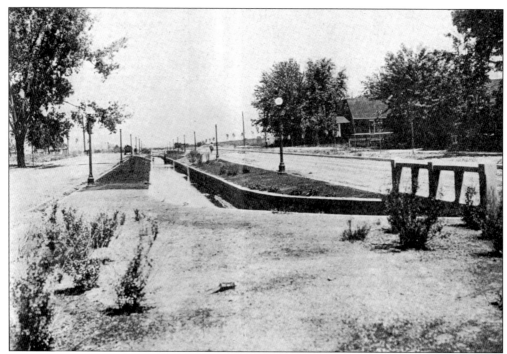

Designed by George E. Kessler, the Marion Street Parkway was named for Josephine Marion. It was begun in 1909 and completed in 1913. It ran from East Virginia Avenue to East Bayaud Avenue at Downing Street. The City Ditch ran within the median and is now covered. It was listed on the National Register of Historic Places in 1986. (Courtesy *Municipal Facts*.)

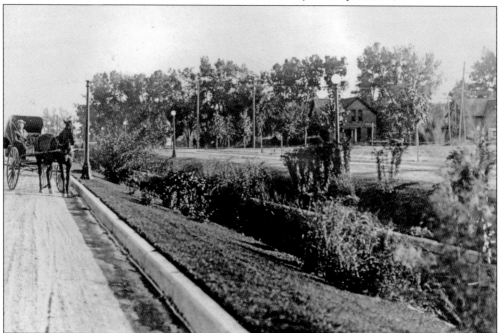

In this 1915 image, landscape architect DeBoer appears in a horse-drawn buggy next to the City Ditch at the Marion Street Parkway. (Courtesy Denver Public Library, Western History Collection.)

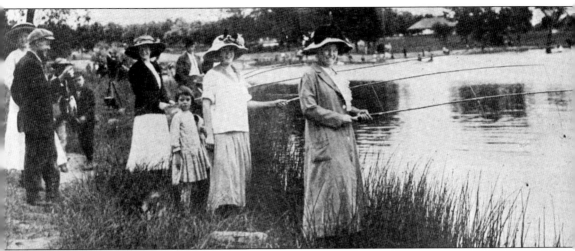

A 1911 photograph shows women fishing at Smith Lake in Washington Park. Smith Lake, the north lake of Washington Park, was named for John W. Smith, a Denver businessman. In 1865, Smith began construction of a ditch from the Platte River to supply water to the area, a project that took two years to complete at a cost of $10,000. He formed the lake that would bear his name from a natural depression in the land. There are now two lakes in Washington Park, Smith and Grasmere, which are connected by a great meadow. Grasmere Lake, completed in 1906, was named for a village in the Lake District of England, the home of William Wordsworth. Designed by German landscape architect Reinhard Schuetze, who had previously worked on Platt Park, the first phase of Washington Park was completed between 1899 and 1908. It is now 162 acres in size. It is bounded by South Downing and South Franklin Streets, between East Louisiana and East Virginia Avenues. (Courtesy *Municipal Facts*.)

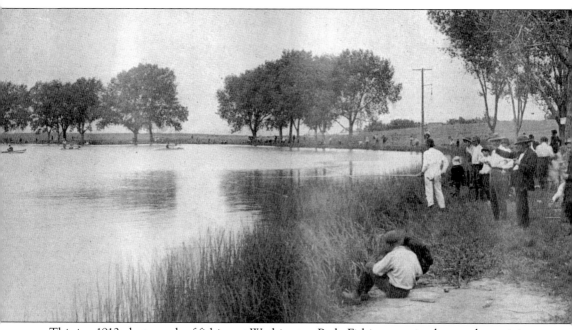

This is a 1912 photograph of fishing at Washington Park. Fishing remained a popular activity at the park for many years. (Courtesy *Municipal Facts.*)

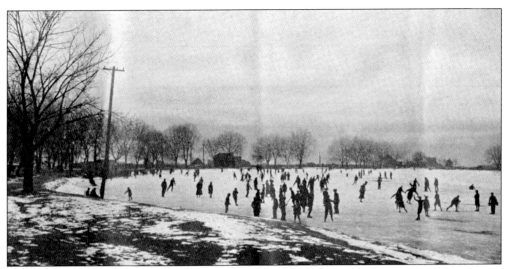

In this 1911 photograph, ice-skaters enjoy a frozen Smith Lake in Washington Park. Ice-skating has long been a popular wintertime activity on the lake. (Courtesy *Municipal Facts*.)

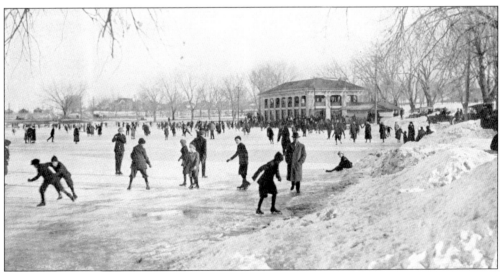

A 1919 photograph of ice-skaters at Washington Park shows the boathouse in the background. (Courtesy *Municipal Facts*.)

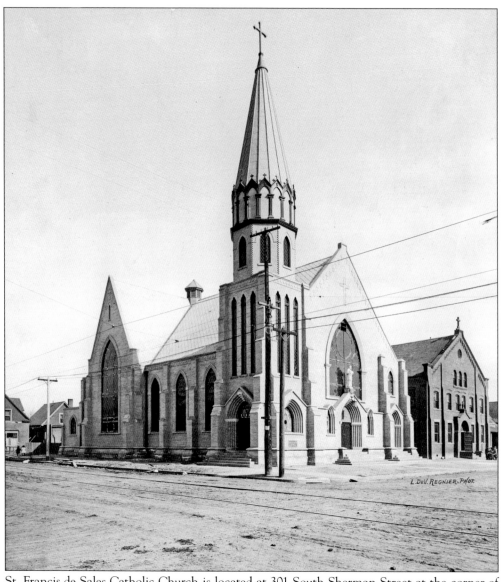

St. Francis de Sales Catholic Church is located at 301 South Sherman Street at the corner of Alameda Avenue. This photograph was taken shortly after the church was dedicated in 1911. A Catholic high school was built on the same block in 1924. The high school closed in 1973 and consolidated with Central Catholic High School. (Courtesy Denver Public Library, Western History Collection.)

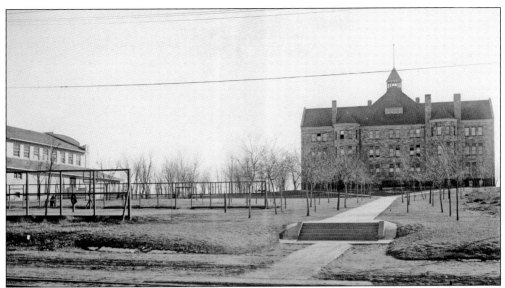

A 1911 photograph features the Alumni Gymnasium and University Hall on the DU campus looking southeast from Evans Avenue. The construction of the Alumni Gym demonstrated the growth of sports and physical education at DU in the early years of the 20th century. It was paid for by alumni of the university, who donated $21,000, and opened in 1910. For many years, DU basketball games and gymnastics meets were held in the gym until the Arena Fieldhouse was built after World War II. After that, it was used primarily by youth groups. It was demolished in 1998 to make way for the new Daniels College of Business Building.

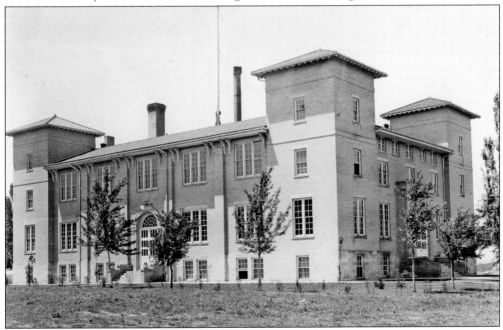

Science Hall was the second building Andrew Carnegie contributed to, donating $50,000 toward construction costs. Carnegie had already given a library to DU. Students later referred to Science Hall as the "gas house" because of the smells coming from the many experiments being conducted inside. The building was demolished in 1997.

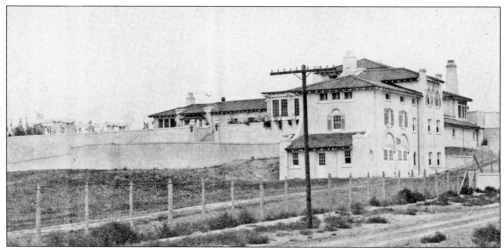

This 1912 photograph is of the John Evans II residence at 2001 East Alameda Avenue, on the corner of Alameda and South Race Street. Evans was the grandson of territorial governor John Evans and was president of the First National Bank of Denver. His Alameda residence was designed by Fisher and Fisher. (Courtesy *Municipal Facts*.)

A gentleman relaxes in Observatory Park in this idyllic 1912 photograph. (Courtesy *Municipal Facts*.)

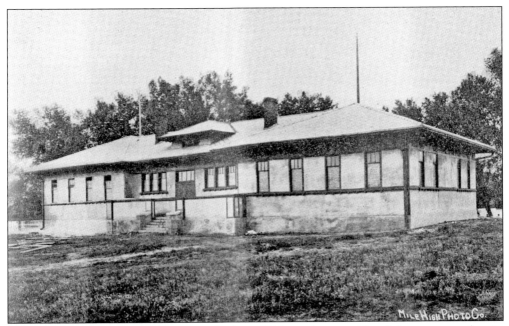

The Washington Park Boathouse was built in 1912 on the east side of the great meadow in Washington Park. (Courtesy *Municipal Facts*.)

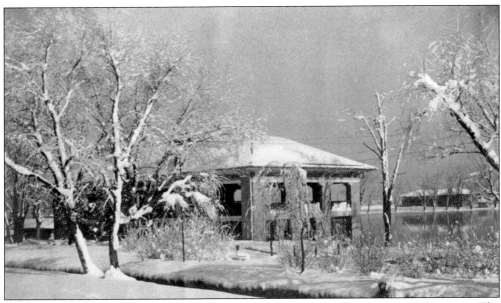

This is a *c.* 1918 photograph of the Washington Park Boathouse/Pavilion covered in snow. The boathouse was designed by J. J. B. Benedict and built in 1913. In the summer, the boathouse was used to store boats, and in the winter it was heated for ice-skaters. (Courtesy *Municipal Facts*.)

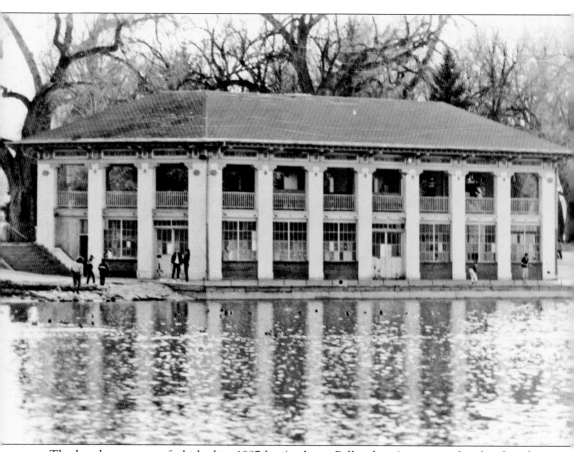

The boathouse was refurbished in 1987 by Anthony Pellecchia Associates shortly after this photograph was taken. (Courtesy the *Washington Park Profile*.)

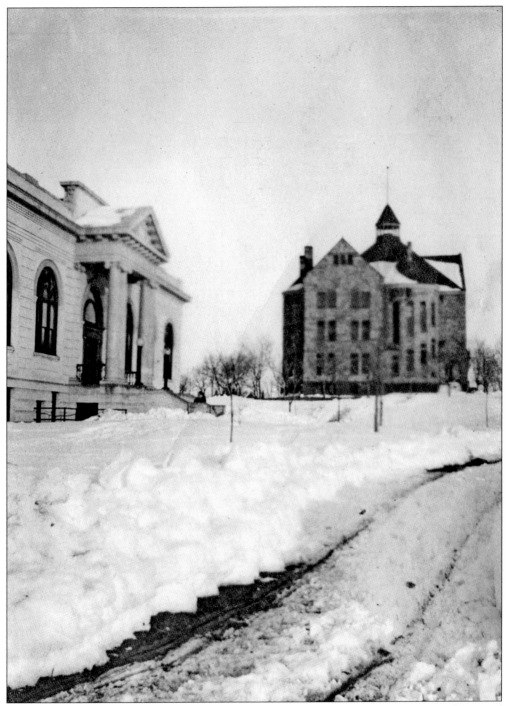

In the great blizzard of 1913, a total of 46 inches of snow fell in Denver between December 1 and December 6. It is still the largest recorded snowstorm to hit Denver. This photograph shows the Carnegie Library and University Hall on the DU campus looking eastward.

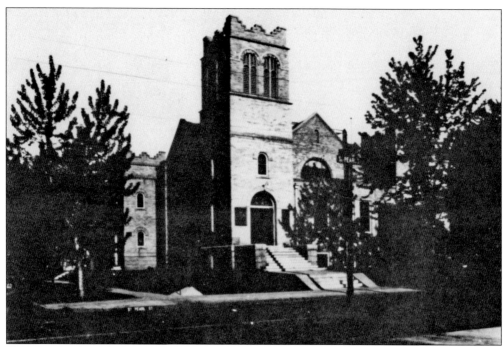

The Cameron Methodist Church was constructed over a three-year period beginning in 1909 and completed in 1912 at South Pearl Street and East Iowa Avenue. This photograph dates from around 1913. The church was located one block east of the original Cameron Church, which had been completed in 1890. It was later used as a youth center. (Courtesy *Municipal Facts.*)

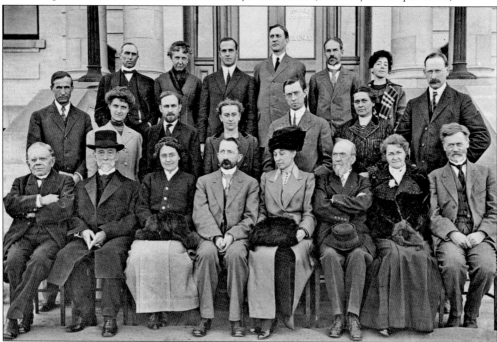

This 1915 DU faculty group shot was taken on the steps of the Carnegie Library. Astronomer Herbert Alonzo Howe is seated in the first row center.

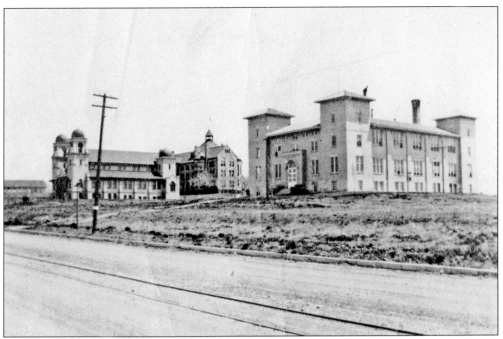

A 1917 shot of the DU campus from Evans Avenue is looking southeast. This photograph shows, from left to right, the Memorial Chapel, University Hall, and the Science Hall.

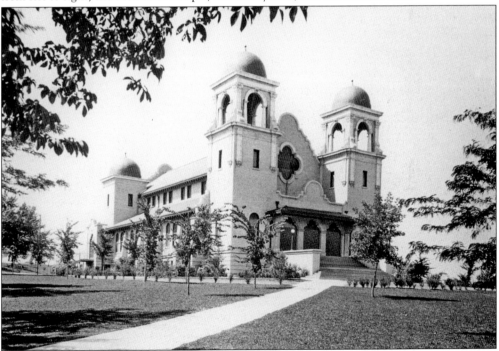

The Memorial Chapel, begun in 1907 but not completed for 10 years because of funding problems, was named in honor of DU alumni who had perished in World War I. Designed by Thomas Barber, it copied the mission-style architecture that Chancellor Buchtel had requested after a trip to California. It was later renamed the Buchtel Memorial Chapel in 1948.

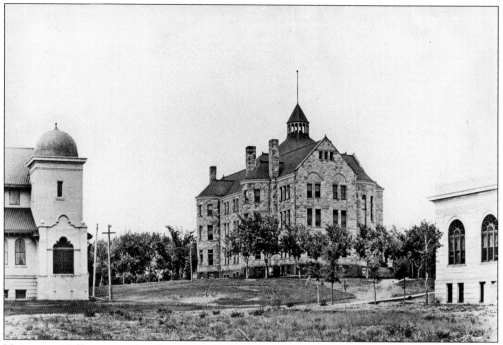

University Hall continued to dominate the landscape as other buildings began to appear on the DU campus in the early 20th century. On the left is the Buchtel Chapel, and on the right is the Carnegie Library.

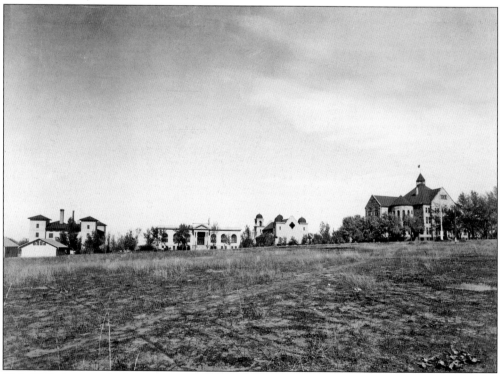

This 1920 photograph shows a view of the campus from a distance looking to the northeast.

A 1917 campus shot looks west with the Carnegie Library on the left, Science Hall just right of center, and to the right the corner of the Memorial Chapel.

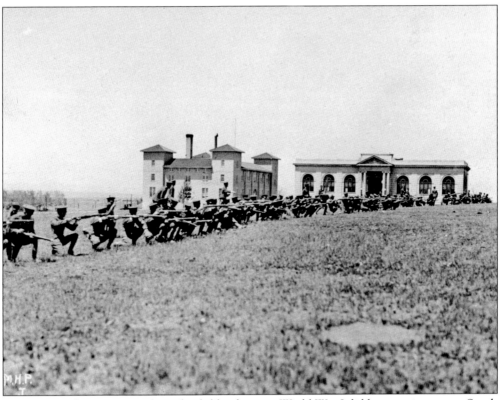

As far as South Denver was from the fields of action, World War I did have an impact on South Denver. The Reserve Officers' Training Corps (ROTC) was founded in 1917, and in this 1918 photograph ROTC students practice rifle skills in a field south of the DU campus.

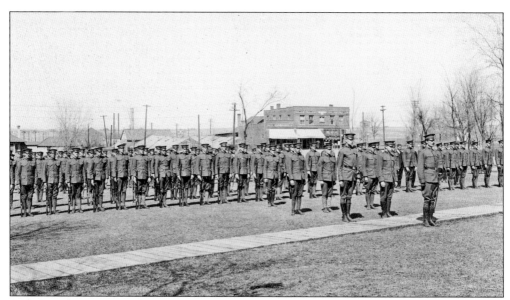

ROTC students in formal dress drill near the southwest corner of South University and Evans Avenue. Note the Floral Building, constructed in 1909, visible in the background. The Floral Building is still in use today. For many years, it housed University Park Pharmacy and now houses Pete's University Park restaurant.

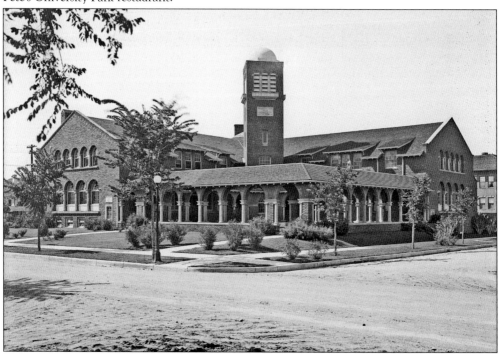

Of Romanesque design, Washington Park Church was designed by the prominent firm of Mareau and Norton. Construction began in 1917 at the northwest corner of Arizona Avenue and South Race Street on land donated by John Evans II and William G. Evans. The building was formally dedicated in 1919. It replaced the earlier Myrtle Hill Methodist Church. It is now referred to as the Washington Park Church. (Courtesy Denver Public Library, Western History Collection.)

This photograph of the Barnitz Memorial Lutheran Church was taken around 1920. The church is located at South Logan and East Dakota Streets in the Washington Park West neighborhood. It was named after poet and Lutheran pastor S. B. Barnitz (1838–1901). (Courtesy Denver Public Library, Western History Collection.)

This 1920 shot of the DU campus was taken from a distance to the south. From here, it is easy to see that the first building, University Hall, was situated at the highest point around.

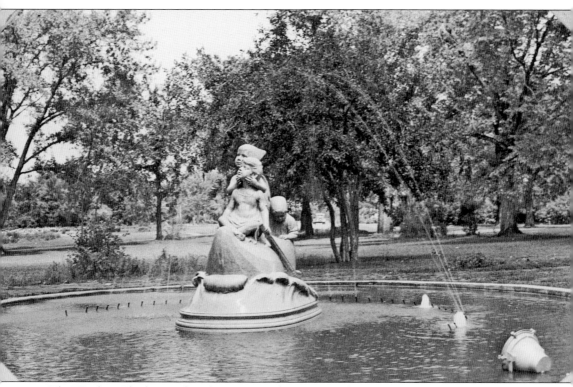

The Wynken, Blynken, and Nod Fountain sculpture in Washington Park is located at the southwest corner of Exposition Avenue and South Franklin Street next to the Eugene Field House. After Field died, the sculpture was commissioned by Mayor Robert Speer in honor of Field's famous characters from his poem "Dutch Lullaby." The sculptor was Mabel Landrum Torrey of Sterling, Colorado, who was paid $10,000 for the piece. It was placed in 1919. (Courtesy Denver Public Library, Western History Collection.)

Three

BETWEEN THE WARS

While most of the country grappled with Prohibition, much of South Denver had already been dry because of the Methodist roots of the area. In the 1920s, Denver Public Schools expanded greatly, with new construction or additions in South Denver at Asbury School, South High School, and University Park School. DU built the new Hilltop Stadium in 1925 and over the next few years built several new fraternity houses.

South Denver and the university were impacted by the Great Depression, but despite this several large building projects were begun, which helped keep local trades busy. Notable among these projects were the Phipps Mansion in the Belcaro area, the Margery Reed and Mary Reed Buildings on the DU campus, expansion of the St. Thomas Seminary, and the construction of the new Montgomery Ward Building on South Broadway Boulevard.

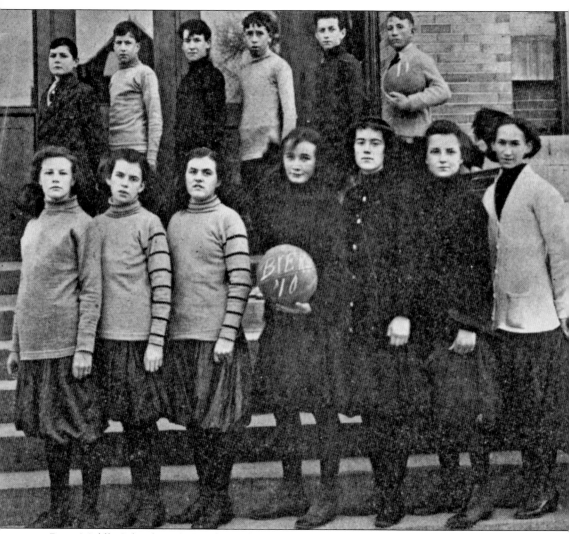

Byers Middle School at 150 South Pearl Street opened in 1921 as a junior high school. That same year, the boys' and girls' basketball teams posed together for a formal picture, seen here. The school was named for William Byers (1831–1903), founder and first editor of the *Rocky Mountain News*. It later served as a site for the Denver School of the Arts until 2003. In 2007, the building was upgraded at a cost of around $500,000 and is now a historic landmark.

Rosedale School, near Harvard Gulch Park, opened in 1924. After several years of declining enrollment, it was closed in May 2005. As of this writing, it stands empty and its fate is uncertain. (Photograph by Phil Goodstein.)

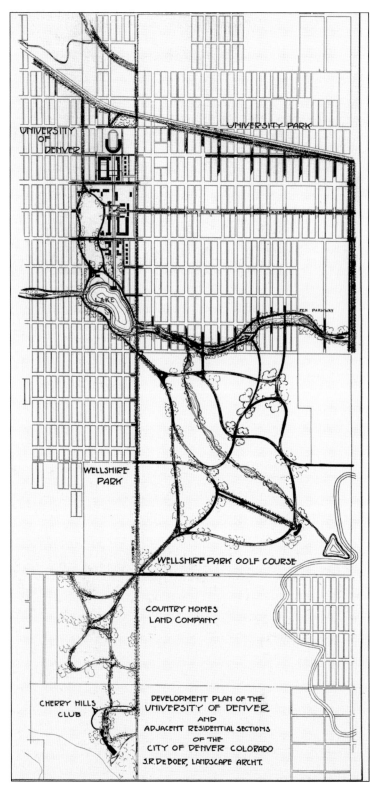

UNIVERSITY OF DENVER

UNIVERSITY PARK

LAKE

PARKWAY

WELLSHIRE PARK

WELLSHIRE PARK GOLF COURSE

UNIVERSITY AVE.

HAMPDEN AVE.

COUNTRY HOMES LAND COMPANY

CHERRY HILLS CLUB

DEVELOPMENT PLAN OF THE
UNIVERSITY OF DENVER
AND
ADJACENT RESIDENTIAL SECTIONS
OF THE
CITY OF DENVER COLORADO
S.R. DE BOER, LANDSCAPE ARCHT.

This 1924 map illustrates the sweeping plan put forth by City of Denver landscape architect S. R. DeBoer. The area covered runs from what is currently I-25 to the north to Cherry Hills in the south. (Courtesy *Municipal Facts.*)

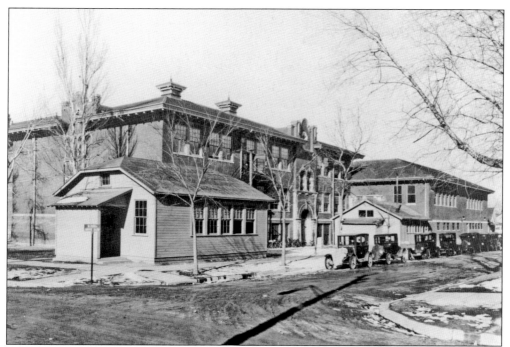

A 1924 photograph shows the old South High School located at Colorado Avenue and South Washington Street. This school stood near the site of the current Grant Middle School. (Courtesy Denver Public Library, Western History Collection.)

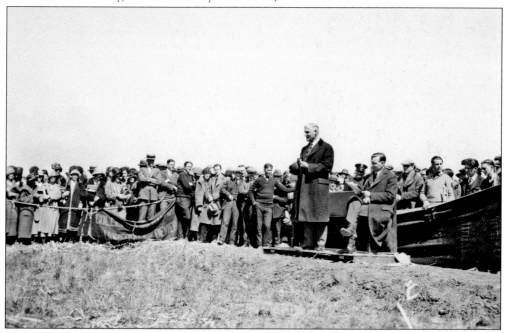

This is a 1925 photograph of the Hilltop Stadium ground-breaking ceremony at DU. The university built a brand-new 25,000-seat stadium at South Race Street and Asbury Avenue to host football games and other major events. It would be a central gathering place in South Denver for the next several decades.

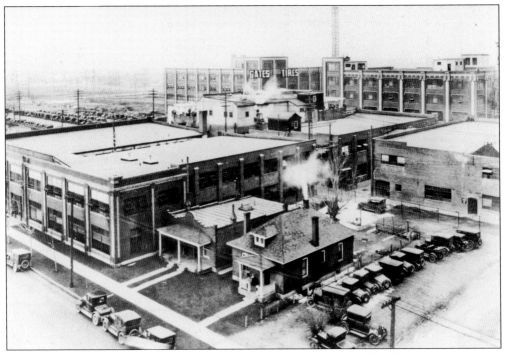

Charles Gates Sr. bought the Colorado Tire and Leather Company in 1911. The company moved from its former location in the 1300 block of Acoma to 999 South Broadway Boulevard in 1914. The name changed to the International Rubber Company in 1917 and then became the Gates Rubber Company in 1919. (Courtesy the *Washington Park Profile*.)

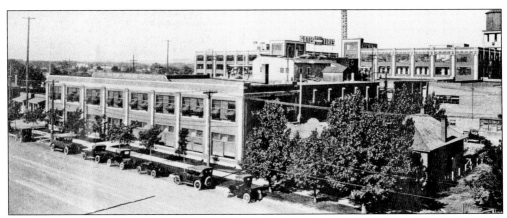

At one time one of the largest producers of automobile belts and hoses in the world, by the 1980s Gates was shifting most of its operations overseas, and in 1995 it closed its Denver operations. The company was sold in 1996. In 2005 and 2006, most of the buildings on the 80-acre site were demolished, and it is now undergoing redevelopment. (Courtesy *Municipal Facts*.)

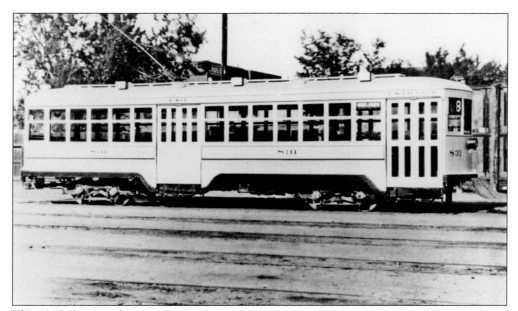

This 1925 photograph shows University Park tramway car No. 831 on Evans Avenue.

The Washington Park Congregational Church, located at 400 South Williams Street, was chartered in 1925. A remodeling of the church by Muchow and Associates was completed in 1958, and today it is home to the Washington Park United Church of Christ. (Courtesy Denver Public Library, Western History Collection.)

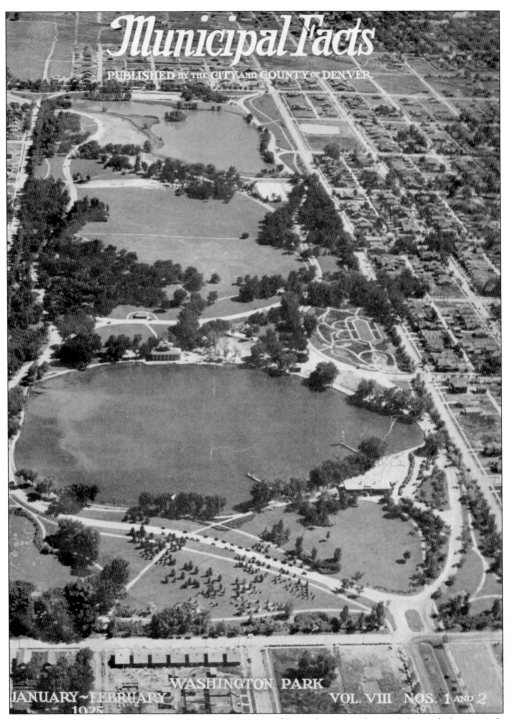

Municipal Facts

PUBLISHED BY THE CITY AND COUNTY OF DENVER

WASHINGTON PARK

JANUARY~FEBRUARY
1925

VOL. VIII NOS. 1 AND 2

This front cover of the January 1925 issue of *Municipal Facts* features a beautiful aerial photograph of Washington Park. (Courtesy *Municipal Facts*.)

Asbury Elementary School is located between Asbury Street and Evans Avenue on South Marion Street. The street was named for Bishop Francis Asbury of the Methodist Church (1745–1816). Asbury was one of the first two bishops of the Methodist Church in the United States. The school was built in 1925, and later additions were made in 1927 and 1947. (Courtesy *Municipal Facts*.)

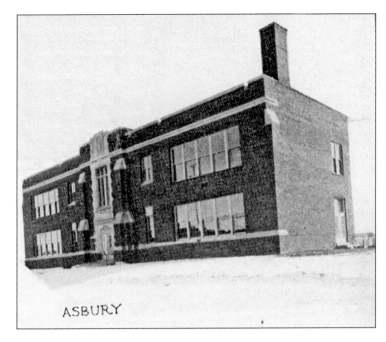

ASBURY

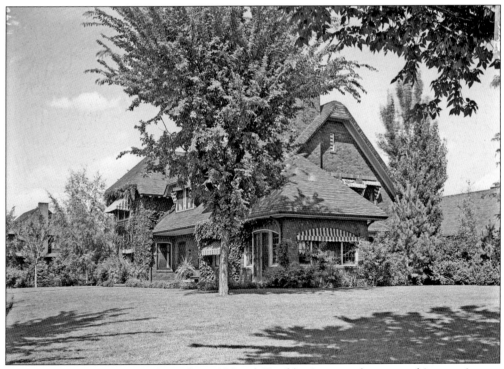

The home of James H. Causey, located at 1198 South Franklin Street on the corner of Arizona Avenue and South Franklin, is a wonderful example of the Tudor Revival style. Causey (1873–1943) was an investment banker and the founder of DU's Social Science Foundation. He was also a member of the DU Board of Trustees. (Courtesy Denver Public Library, Western History Collection.)

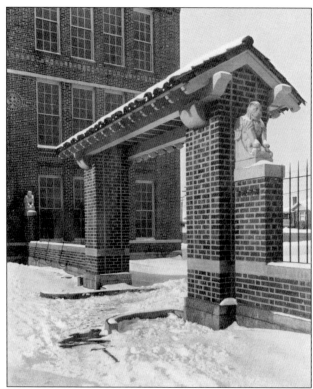

Designed by Fisher and Fisher at a cost of just over $1 million, Denver South High School was opened in 1926 and sits at the southeast corner of Washington Park at 1700 East Louisiana Avenue. It is a four-story building done in the Italian Renaissance Revival style. It features statues of monsters and griffins created by sculptor Robert Garrison. (Courtesy *Municipal Facts.*)

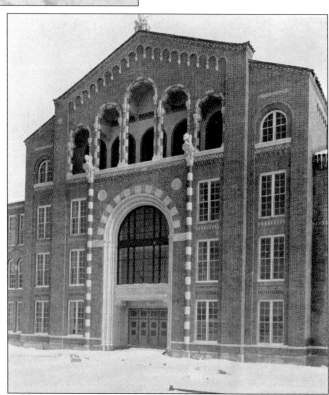

A 1926 photograph shows the new Denver South High School's central entrance. (Courtesy *Municipal Facts.*)

In this 1928 photograph, men in uniform raise the flag at Denver South High School. (Courtesy Denver Public Library, Western History Collection.)

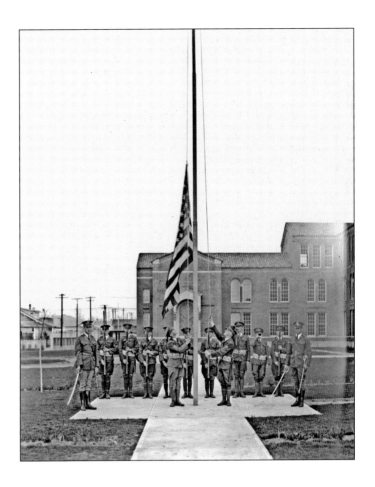

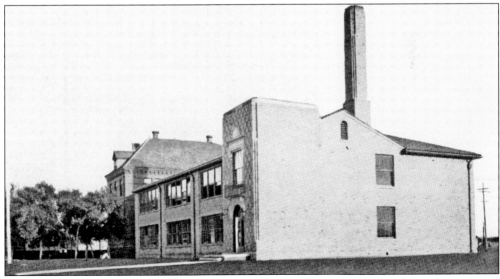

In 1924, University Park School boasted a new addition. (Courtesy *Municipal Facts*.)

A 1926 photograph reveals the recently remodeled entrance to University Park School just east of the park. (Courtesy *Municipal Facts*.)

A group of dapper young men pose in front of a South Pearl Street grocery and meat market in this 1926 photograph. (Courtesy the *Washington Park Profile*.)

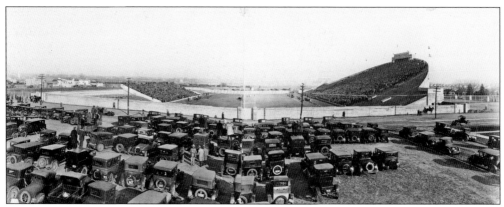

Traffic and parking issues in the university area may seem like a recent problem, but even in 1927, during a football game at Hilltop Stadium, parking could become challenging. Parking "lots" were tiny by modern standards.

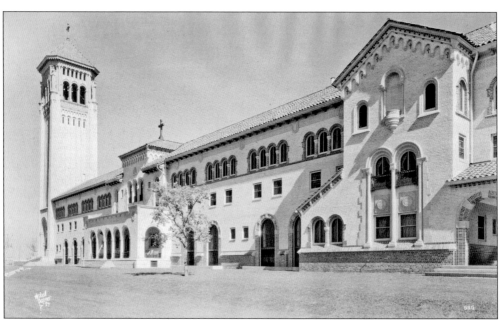

The first structure on the St. Thomas Seminary property was built in 1908. It was later expanded by Denver architect Jacques Benedict from 1926 to 1931 in the Lombard style of architecture of Northern Italy. The first seminary closed in the early 1990s and became home to the Denver Archdiocese. In 1999, a second seminary opened, the St. John Vianney Theological Seminary. (Courtesy Denver Public Library, Western History Collection.)

Among the many activities one could pursue in Washington Park was lawn bowling. A lawn bowling club was established in the park in 1925 and still exists today. (Courtesy *Municipal Facts*.)

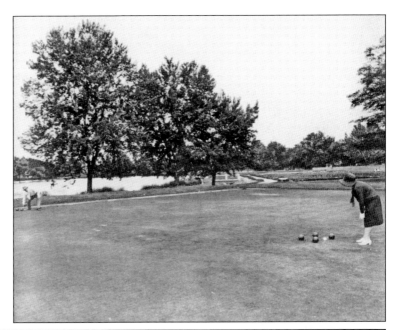

A 1929 photograph shows the John Morey residence at 1929 East Alameda Avenue, a modified Mediterranean-style home located just south of the Denver Country Club. The home was designed by Burnham Hoyt. It was owned by John Morey (1878–1956) of the Morey Mercantile Company. He was the founder of Boys Clubs of Denver and a director of the Denver Tramway Corporation. After Morey's death in 1956, his daughter Katherine and her husband, John A. Ferguson Jr., moved into the residence, and it became known as the Morey-Ferguson residence. (Courtesy Denver Public Library, Western History Collection.)

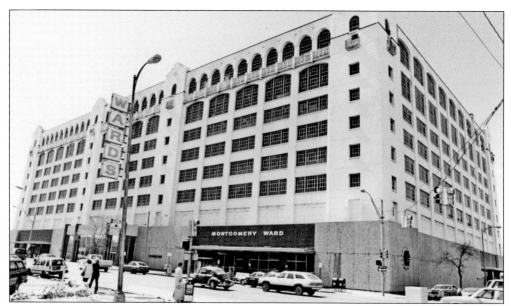

The Montgomery Ward store on South Broadway Boulevard was constructed in 1929, the first full department store in the area and a popular shopping destination for more than 50 years.

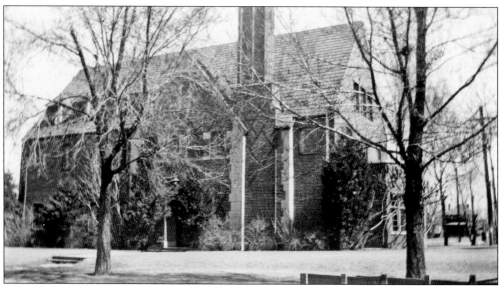

DU constructed several fraternity houses in the late 1920s on the north side of Evans Avenue, including the Beta Theta Pi house. These houses later became known as "old row," as newer fraternity houses were built east of South University Boulevard. Today only Beta house remains of the original "old row"; the other houses have been demolished and rebuilt.

The Margery Reed Building on the DU campus was completed in 1928 and named for the daughter of Verner and Mary Reed. Margery graduated from DU in 1919 with a bachelor of arts in English. That year, she took a position as an assistant professor at DU and met future husband Paul Mayo, who also taught English. In 1924, they traveled to Peru, where Margery became ill. They returned to the United States, where she died in 1925 at the age of 31. Mary Reed donated $100,000 in her daughter's memory for the construction of the $225,000 building, which housed the theater department.

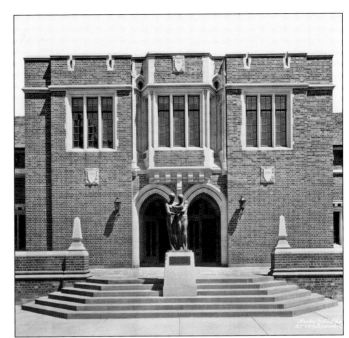

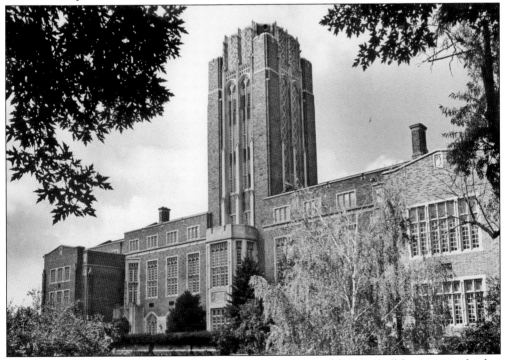

Following the death of her husband, Verner, in 1919, Mary Reed (1875–1945) became involved in charitable philanthropic projects. Not long after her gift to construct the Margery Reed Building at DU, she donated an additional $350,000 in cash and $180,000 in trust fund income to construct the library that bears her name. Designed by Henry James Manning in Collegiate Gothic style, it opened in 1933. In 1972, with the building of the new Penrose Library, the Mary Reed Building became home to DU administrative offices and classrooms.

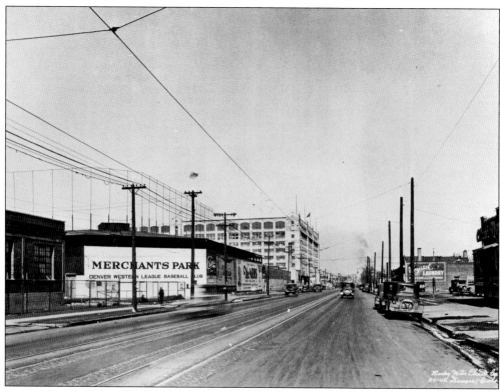

Originally called Union Park, Merchants Park was built in 1901 and later enlarged in 1922 through donations from the Merchants Biscuit Company. A South Broadway Boulevard landmark, Denver Bears baseball games were played there through 1948, when Bears Stadium (later to become Mile High Stadium) was built. Merchants Park Shopping Center opened in 1951. (Courtesy the *Washington Park Profile*.)

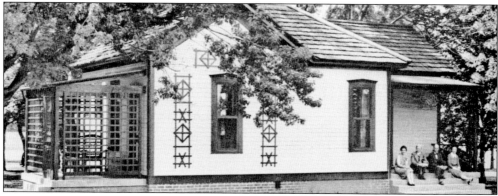

Eugene Field (1850–1895) was a famous poet who lived in Denver for just two years, from 1881 to 1883. While here, he was editor of the *Denver Tribune*. His Denver home was originally built in 1875 on West Colfax Avenue, but when it was threatened with demolition it was moved with funds raised by Margaret "Molly" Brown to Washington Park in 1930. It was used as a public library for the next 40 years. (Courtesy *Municipal Facts*.)

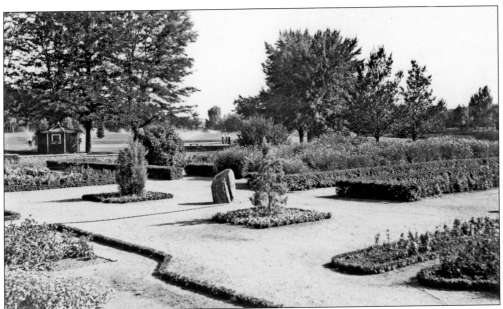

The Mount Vernon Gardens in Washington Park were an exact model of Martha Washington's gardens at Mount Vernon and were planted in 1926 at the request of Mayor Stapleton. In this 1930 photograph of the gardens, the lawn bowling office and bowlers in the distance are visible. (Courtesy Denver Public Library, Western History Collection.)

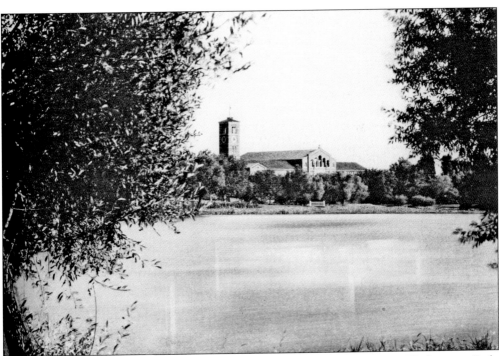

This 1930 photograph depicts the view of Denver South High School from Washington Park. (Courtesy *Municipal Facts*.)

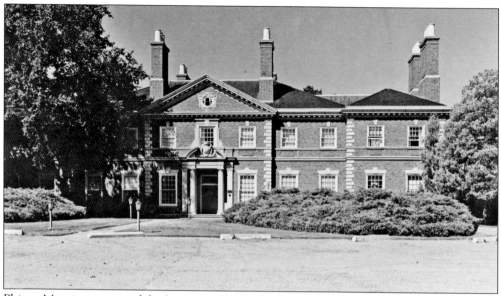

Phipps Mansion is named for Lawrence C. Phipps, one-time vice president and treasurer of Carnegie Steel Company in Pittsburgh. Phipps was born in Pennsylvania in 1862. He relocated to Colorado in 1902. He served as a Republican senator from Colorado for 12 years, from 1919 to 1931. His mansion of Georgian design was known as Belcaro, which is Italian for "dear one." It was designed by Fisher and Fisher and Charles A. Platt. Completed in 1933 at 3400 Belcaro Drive, the mansion cost over $300,000 to build and has 54 rooms. Phipps passed away in California in 1958. In 1964, the 5-acre estate was given to the University of Denver by his widow. It is now commonly referred to as Phipps House, though its formal name is the Lawrence C. Phipps Memorial Conference Center.

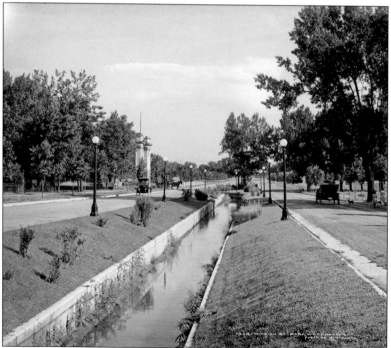

This 1938 photograph shows the completed Marion Street Parkway, which led to the entrance of Washington Park. The boathouse is visible in the distance.

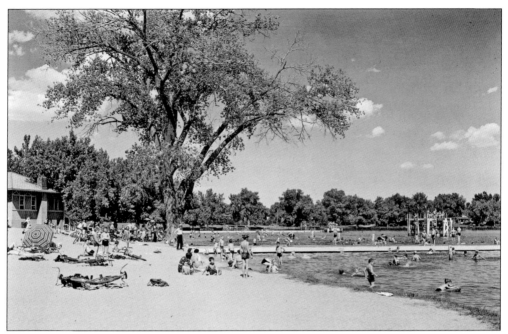

Swimming was allowed at Washington Park on the north end of Smith's Lake from 1911 until 1955, when it was halted because of the high cost of chlorination. In this 1940s photograph, the Washington Park Bathhouse is visible to the left. (Courtesy Denver Public Library, Western History Collection.)

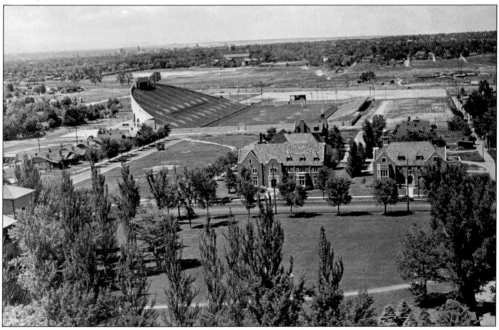

This 1940s photograph was taken from the Mary Reed tower on the DU campus and shows an empty Hilltop Stadium, "old row" fraternity houses along Evans Avenue, and Denver South High School in the distance. The vacant area that would later become I-25 is visible beyond the stadium.

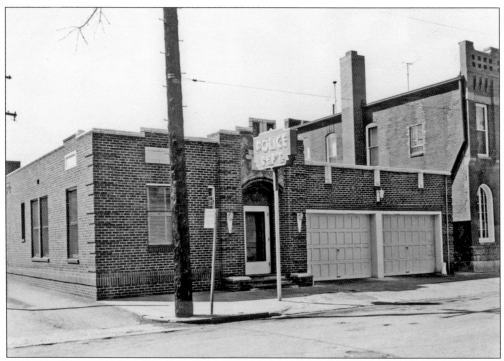

A 1940s photograph shows the South Denver Police Station located at 20 East Center Avenue. The building was first occupied in 1931 and is today used by the Denver Fire Department to store supplies. It is currently being considered as the site for a police museum. (Courtesy Denver Public Library, Western History Collection.)

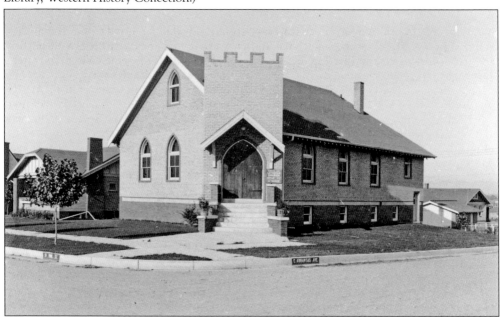

Washington Park Lutheran Church, which was located at 1415 South Vine Street at the corner of East Arkansas Avenue, is pictured in the 1940s. Today the structure houses the St. Mark's Parish Orthodox Christian Church. (Courtesy Denver Public Library, Western History Collection.)

Four

POSTWAR EXPANSION

Many service personnel were stationed in Colorado during World War II, and they were impressed with the natural beauty of the state. That and Denver's mild climate attracted many of these individuals to relocate after the war. The GI Bill paid for veterans to attend college, and after a large drop in student population during the war, DU's attendance swelled to the highest numbers in its history. DU became known as "GI Tech." Temporary housing units sprang up all over the campus area. One was known as Pioneer Village. Fortunately the federal government was generous in providing funding for housing. DU took advantage of this in constructing several permanent housing units, such as Aspen, Hilltop, and Pioneer Halls, for married students.

In the 1950s, South Denver saw the opening of the first two malls in the area, the Cherry Creek Mall and the University Hills Mall. With more people able to afford automobiles, shopping malls would become a routine destination. Increased use of automobiles and buses signaled the end of Denver's streetcar system, which ceased operation in 1950.

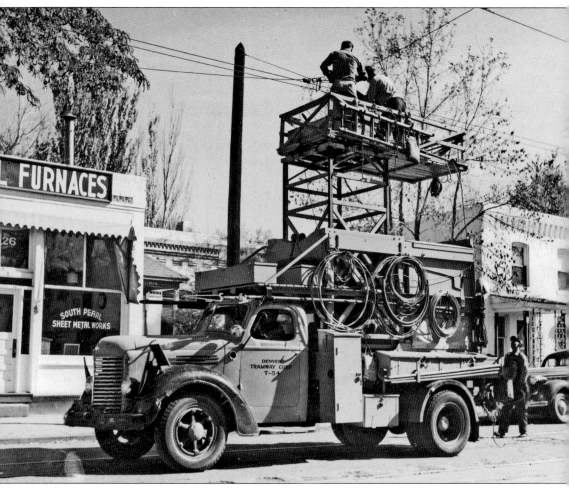

Workers on the Denver Tramway Corporation line truck No. T-54 install trolley coach wires on the 1500 block of South Pearl Street in this 1949 photograph. (Courtesy Denver Public Library, Western History Collection.)

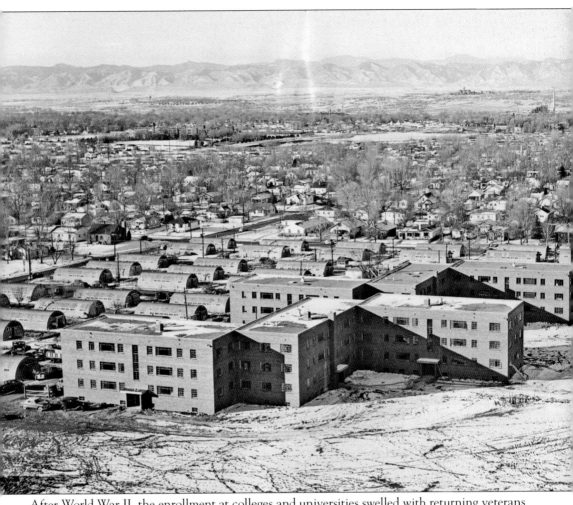

After World War II, the enrollment at colleges and universities swelled with returning veterans going to school on the GI Bill. DU enrollment swelled to nearly 12,000 students, of which 7,500 were veterans. The university had to erect temporary Quonset huts to keep up with the demand for student housing. This picture shows a village of huts on Iliff Avenue near South High Street.

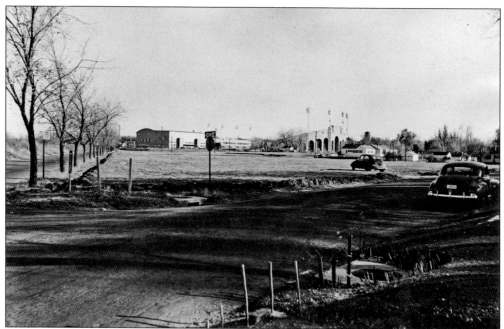

In this photograph taken from Buchtel Boulevard and South Williams Street, which dates from the early 1950s, the new DU Fieldhouse is visible next to Hilltop Stadium. The Fieldhouse was a former navy drill hall in Idaho, which was given to DU by the federal government after World War II. It was disassembled, shipped to Denver in pieces, and reassembled. In time it became known as "the old barn" to DU sports fans.

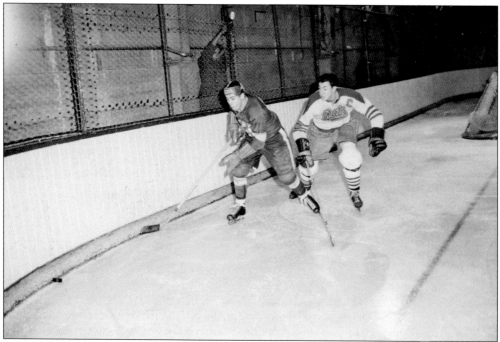

DU began playing intercollegiate hockey in the Fieldhouse in the late 1940s, and it quickly caught on, not just with the DU community but with the public at large.

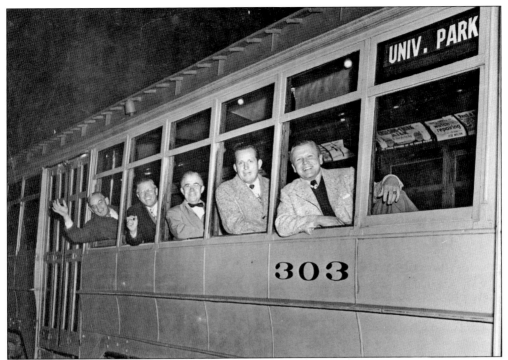

DU administrators rode the last University Park Tramway car in 1950. Denver had begun replacing streetcar lines with buses as early as 1930, a process that was completed by 1950.

The DU Pioneer Square Dancers pose in this 1950 photograph on the west side of the Mary Reed Building. This popular group performed extensively around the region. Note the unobstructed view of the front range to the west, a view now largely obstructed by the growth of trees and much needed campus expansion.

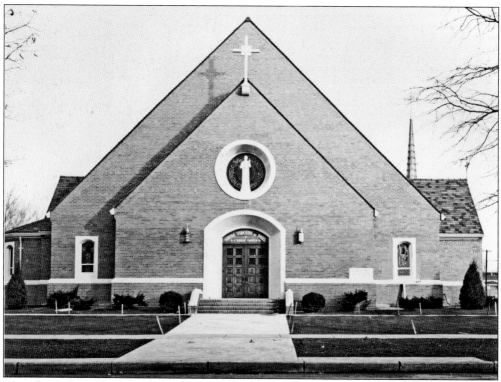

A 1951 photograph shows St. Vincent de Paul Catholic Church, located at 2375 Arizona Avenue. The church was constructed in 1926. (Courtesy Denver Public Library, Western History Collection.)

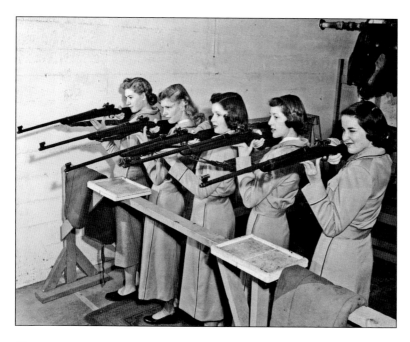

Members of the DU ROTC Association Ladies Club practice their marksmanship in this January 1952 photograph.

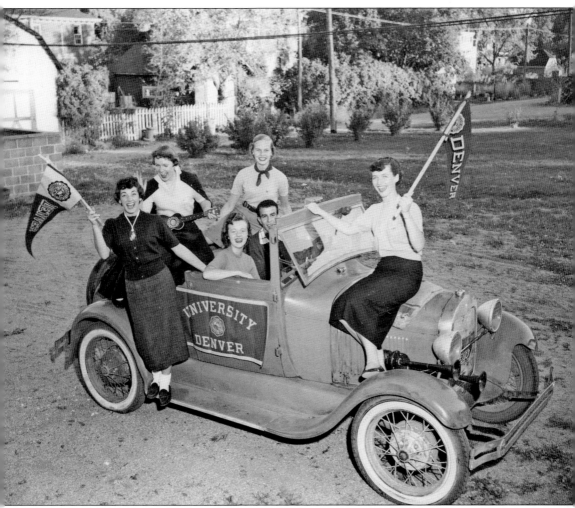

In this 1954 DU Homecoming photograph, students pose in a classic car with their pennants.

The University Hills Mall opened in 1955 on the site of what had been an old ranch called Diamond Joe's in the latter part of the 1800s. Originally called the University Hills Center, it was located on Colorado Boulevard near Yale Avenue. It was the second open-air mall in the region, coming just two years after the opening of the Cherry Creek Mall. (Courtesy the *Washington Park Profile*.)

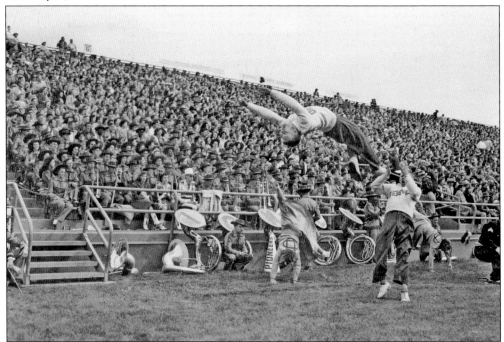

Cheerleaders are at a DU football game in Hilltop Stadium in this 1955 photograph. The DU marching band is visible sitting in the stands. At this time, DU's mascot was Pioneer Pete, and many supporters dressed in buckskin and cowboy hats.

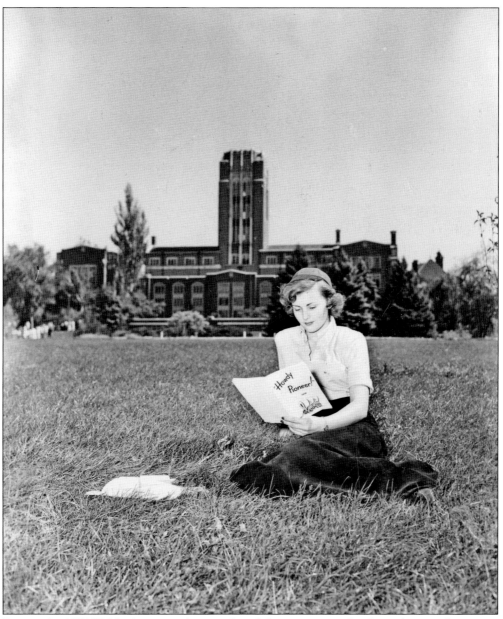

During the 1955 DU freshman week, a coed reads her orientation book on the open lawn west of Mary Reed Library. This area is now a part of the Humanities Garden.

DU freshman are pictured at the Senior Fence in 1953. For many years, the painting of the Senior Fence on the north side of the circle between University Hall and the Iliff Building was an honored tradition. The fence was given by alumni to the senior class of 1916, copying an older Ivy League tradition. A rivalry then developed with the freshman class over who would paint the fence first.

The freshman orientation picnic was another long-standing DU tradition. Here the freshmen gather on the lawn northwest of the Mary Reed Building in the mid-1950s.

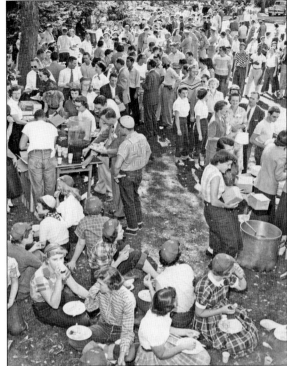

A 1957 photograph shows freshman in their required beanies. The freshman beanie tradition was taken quite seriously at DU, as it was in most colleges throughout the 1950s. Strict rules governed the wearing of the beanie, when it could be worn, and where.

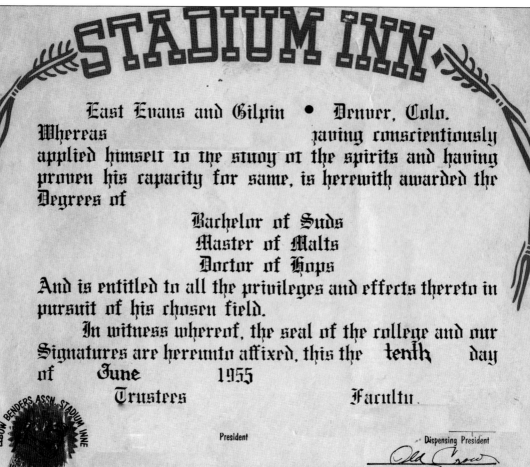

STADIUM INN

East Evans and Gilpin • Denver, Colo.

Whereas _____ having conscientiously applied himself to the study of the spirits and having proven his capacity for same, is herewith awarded the Degrees of

Bachelor of Suds
Master of Malts
Doctor of Hops

And is entitled to all the privileges and effects thereto in pursuit of his chosen field.

In witness whereof, the seal of the college and our Signatures are hereunto affixed, this the **tenth** day of **June** 1955

Trustees Faculty

President Dispensing President

Secretary Dean

The Stadium Inn, named for the nearby Hilltop Stadium, is a longtime DU hangout located at South Gilpin Street and Evans Avenue. In the 1950s, fake stadium diplomas like this one were given out. Today the Stadium Inn is still going strong despite the fact that Hilltop Stadium has been gone for many years.

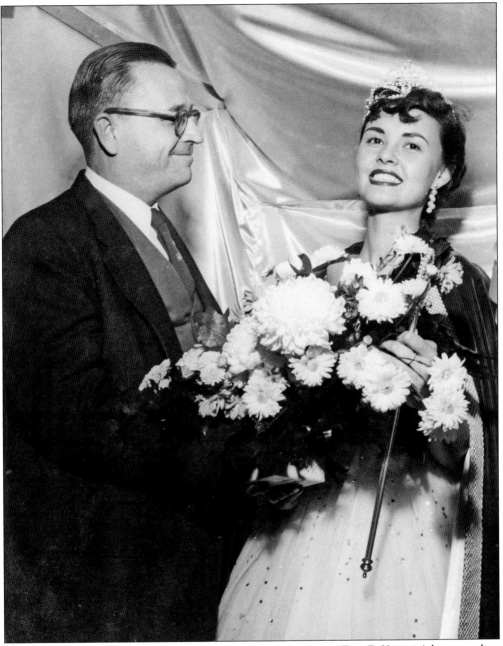

DU chancellor Chester Alter poses with 1956 Homecoming Queen Fran DeYoung. A long-standing DU tradition was for the chancellor to crown the annual homecoming queen.

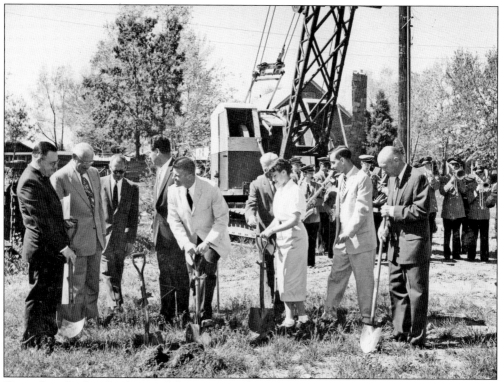

Ground was broken for the new Johnson-McFarlane Dormitory at DU in 1957. Commonly called "J-Mac," Johnson-McFarlane cost $1.7 million to build and opened in 1958. It was named for two early DU faculty members, Granville "Granny" Johnson and Ida Kruse McFarlane. Johnson taught physical education at DU for 20 years, while McFarlane taught English for 33 years.

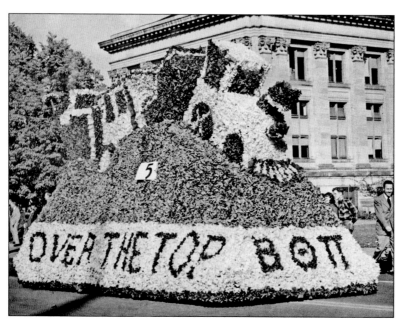

DU Homecoming parades were so popular through the 1950s that the parade was held in downtown Denver, and the city stopped to view it. Here is the Beta Theta Pi float in the 1958 parade.

Five

THE 1960S AND BEYOND

After the relative quiet of what historians would later call the "do nothing" 1950s, the 1960s exploded in politics, arts, and culture. The civil rights movement and the Vietnam War often dominated the news. Student protests followed at DU as they did at most every American college and university. Also in the 1960s, DU dropped football and celebrated its centennial. In the 1970s, DU built a new library and a new art building. In the 1980s, two historic structures were lost to fire, the Buchtel Chapel at DU and the Thomas Field House in Harvard Gulch Park. Varsity Lanes bowling alley closed, as did the original Eugene Field branch of the Denver Public Library, replaced by a new facility in the Bonnie Brae area. DU acquired Colorado Women's College (CWC) at Montview Boulevard and Quebec Street and moved its law school there from its former downtown location. DU's music school also moved to the CWC campus.

The demographics of South Denver also changed in the 1970s and 1980s, as many older retirees who had occupied single-family homes for years moved into retirement homes or assisted-living communities. Many of their homes became rental properties, and with more occupants per household, parking and traffic issues arose. Later many homes were "scraped" or "popped" and rebuilt to add additional square footage. This happened primarily because South Denver continued to be viewed as a desirable place to live with affordable smaller-sized homes on fairly large lots.

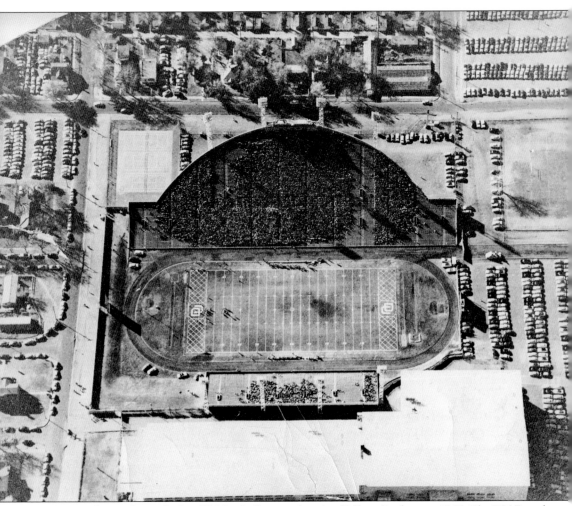

An aerial view shows the last DU football game played at Hilltop Stadium in 1960. The DU Board of Trustees voted unanimously to terminate football on January 9, 1961, citing annual losses of over $100,000. DU had played football since 1884.

The Denver Clarion

Toward a better
informed University
Community

UNIVERSITY OF DENVER

Volume 37, No. 22 Tuesday, January 10, 1961 Denver, Colorado

No More Football

"Snow Queen" finalists for the first DU Winter Carnival are Carolyn Styke, Sharon Bohlen and Nancy Sand and Linda Dudley. Not pictured is Lou Luske. George Congraves will present the Queen at the hockey game Friday, Jan. 13. — photo by Duane Howell

Chancellor Alter's Statement

"The Board of Trustees of the University of Denver voted unanimously today to terminate participation in intercollegiate football, effective immediately.

"The growing magnitude of cost associated with intercollegiate football and the continuing hazard of substantial financial loss was the primary reason for this decision by the Board. Football at the University of Denver has become prohibitively expensive. It is not feasible to continue a single intercollegiate athletic activity which produces an annual deficit of about $100,000.

"At the same time the Board expressed its conviction that the University must maintain its responsibility to develop in the youth of our nation those qualities and habits that contribute to physical fitness. It is the intent of the University that these objectives be accomplished through continued effective instruction in a well-balanced curriculum in physical education, an expanded program of intramural sports and participation in intercollegiate competition in carefully selected sports deemed appropriate to our unique situation.

"The utilization of playing fields heretofore largely limited to use by students engaged in intercollegiate football will more fully meet the needs of an increasing number of students, both men and women, who wish to participate in sports and recreation.

"Evidence of the need for additional facilities is seen in the fact that during the past academic year there were over 2400 participants in the men's intramural sports program at the University of Denver, an increase of approximately 30% over the past two years.

"The University of Denver will continue to offer financial assistance to our currently enrolled football players so long as they remain in good standing, in order to make it possible for them to complete their educational objectives within the normal four-year period.

"The University takes this opportunity publicly to express gratitude to Mr. John Roning, the head football coach, and to his assistants who have performed their duties in an able and conscientious manner. Mr. Roning has tenure at the University of Denver as a full professor and will remain at the University as a member of the faculty.

"The University expresses its profound gratitude to those devoted individuals and groups who have consistently demonstrated their support of the University's athletic program. It wishes to assure these loyal supporters that it will continue to provide in the future a vigorous athletic program in which we hope they will take great pride.

"Institutions with which the University has scheduled games will be notified immediately of this decision. In view of the fact that the Mountain States Athletic Conference is truly an athletic conference rather than a football conference, the University of Denver expects to continue as a member of this Conference which has provided us such excellent opportunity for joint participation in many sports with these fine institutions of the Rocky Mountain Region."

Ski Club Announces 'Snow Queen' Finalists

The first Denver University Winter Carnival will officially begin Friday night, Jan. 12, at the DU-North Dakota ice hockey game with the crowning of the "Snow Queen."

Five finalists from a total of 15 candidates were selected in pre-judging. The finalists are: Linda Jene Dudley, freshman and International Relations major from Arlington, Va.; Sharon Bohlen, freshman, undeclared major from Denver; Lou Luske, junior, speech major from Elmhurst, Ill.; Nancy Sand, freshman, political science

dance, raffle and parade has been set to accompany the singular ski team exhibition. Weather permitting, snow sculpture entries and judging are also scheduled.

The Student Senate had declared the Winter Carnival has a class A function. This means that the Winter Carnival has the same status as Homecoming, Greek Week, and May Days.

The Pioneer Ski Club is in charge of the Winter Carnival and all plans have been made by the club for the presentation of the

Newman to Serve As 1961 May Days Over-all Chairman

Joe Newman, junior from Darien, Conn., has been appointed 1961 May Days chairman by the Student Senate.

Newman, majoring in psychology and minoring in education, is also very active in fraternal and university organizations. He is a member of Phi Kappa Sigma fraternity and holds the office of social chairman.

The DU student newspaper, the *Clarion*, headlined the end of football in 1961.

99

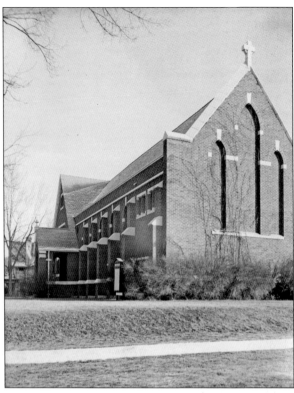

University Park Methodist Church, located at 2180 South University Boulevard across from the DU campus, was originally constructed in 1927 in the late Gothic Revival style by Denver architect Walter H. Simon. It was expanded in the 1950s.

DU founder John Evans built the Evans Memorial Chapel around 1878 at Thirteenth Avenue and Bannock Street near downtown Denver in memory of his daughter Josephine Evans Elbert, who died during childbirth in 1868 at the age of 24. Built at a cost of $13,000 in the Gothic Revival style, the chapel was a part of Grace Methodist Church from 1889 to 1953. It was threatened with demolition in 1959 to make way for a parking lot. It was instead dismantled and moved in pieces to the DU campus in 1960 at a cost of $80,000. The Evans family funded the move. It was placed in the National Register of Historic Places in 1974 and given landmark status in 1988. It is the oldest Protestant church in the city still in use. It is a popular venue for weddings.

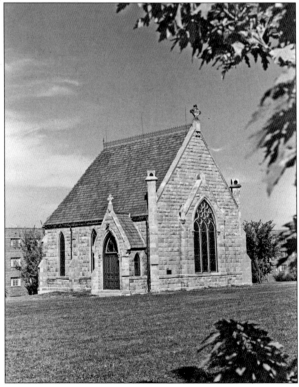

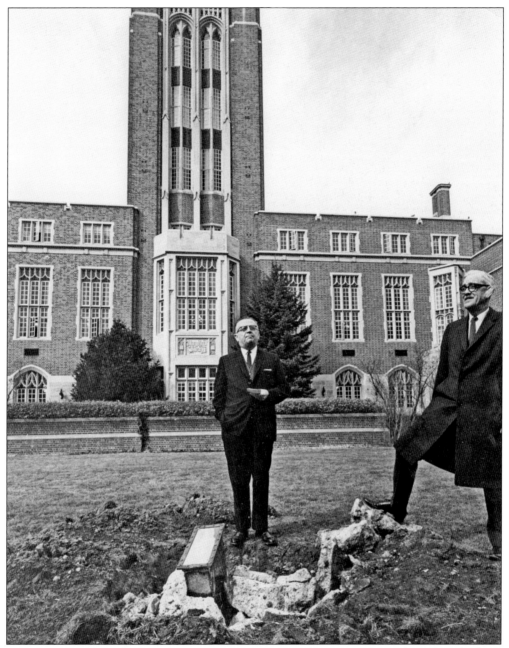

In 1964, DU celebrated its 100th anniversary. A centennial time capsule was buried on the lawn in front of the Mary Reed Building. On the left is DU chancellor Chester Alter, and on the right is Russ Porter, a DU professor who organized the centennial festivities.

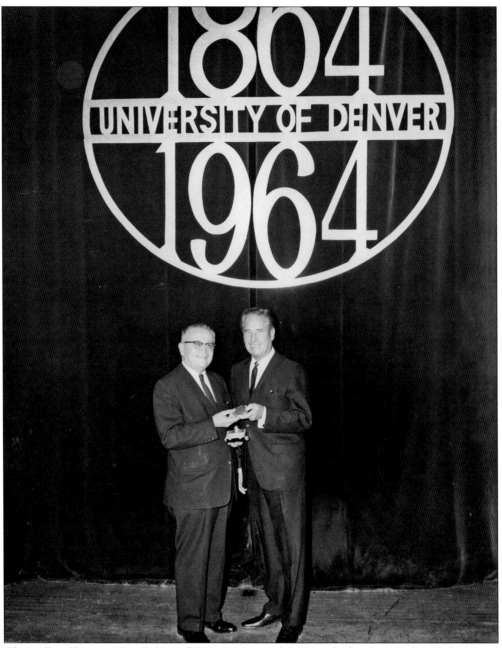

Chancellor Chester Alter (left) and DU chairman of the board of trustees Robert Selig unveil the DU centennial logo and medallion. DU had planned for its centennial for a number of years, and the celebration featured a large number of visiting speakers and dignitaries.

Lady Bird Johnson, wife of then president Lyndon Johnson, visited the DU campus and planted a tree as part of the Harper Humanities Garden dedication ceremonies on September 19, 1965. The garden was named for Dr. Heber R. Harper, a former DU chancellor who donated $100,000 toward its construction. The First Lady planted a pinion oak tree, which still stands in the garden.

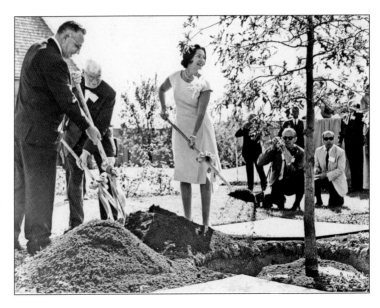

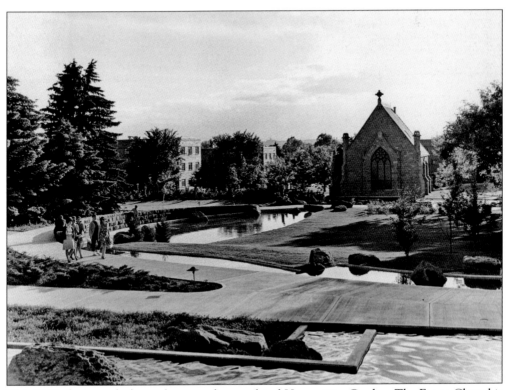

This 1967 photograph shows the recently completed Humanities Garden. The Evans Chapel is visible in the background.

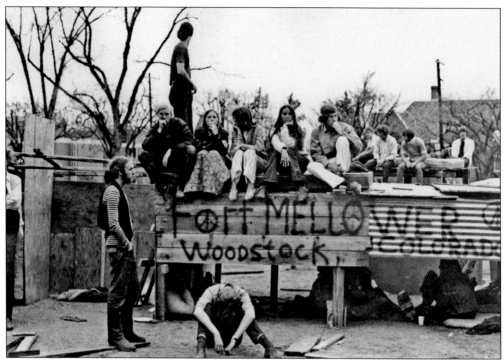

A large student protest that came to be known as "Woodstock West" developed on the DU campus for several days in early May 1970 after the Kent State shootings. A tent village arose near what is now Penrose Library on Evans Avenue. The tents were torn down after five days by the Colorado National Guard and the Denver police. Unlike many universities across the country, DU remained open throughout the protest. Chancellor Maurice Mitchell felt that the campus should remain open to be a place of dialogue and discussion.

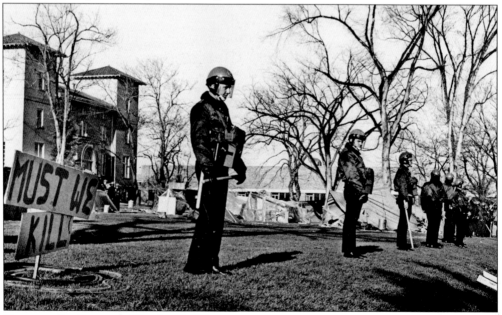

Denver police line up at Woodstock West.

This photograph was taken around the time of the closing of the Eugene Field branch library in Washington Park at East Exposition Avenue and South Franklin Street in 1970. It was replaced by a larger facility with the same name at South University Boulevard and East Ohio Avenue in the Bonnie Brae area. The old Field Library had been the smallest library branch in the Denver Public Library system. That same year, the structure was designated a Denver landmark and added to the National Register of Historic Places in 1979. The former branch library is now the headquarters of the Park People organization. (Courtesy Denver Public Library, Western History Collection.)

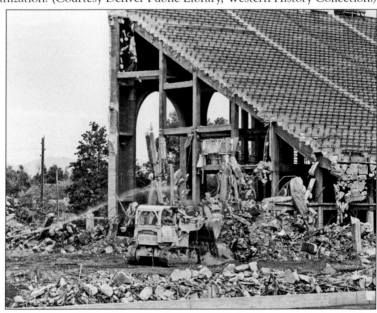

DU's Hilltop Stadium was demolished in 1971, ten years after DU dropped football. The stadium, built in 1925, was in need of extensive maintenance. A move to save the concrete statues on the stadium failed after it was determined that they could not be separated from the primary structure.

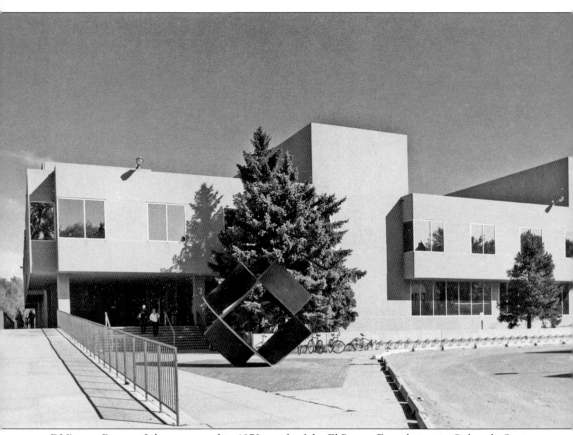

DU's new Penrose Library opened in 1972, a gift of the El Pomar Foundation in Colorado Springs. It was a fast-track building constructed for $7.5 million in a southwestern style. It replaced the Mary Reed Library, which had long ago run out of space and did not lend itself to expansion.

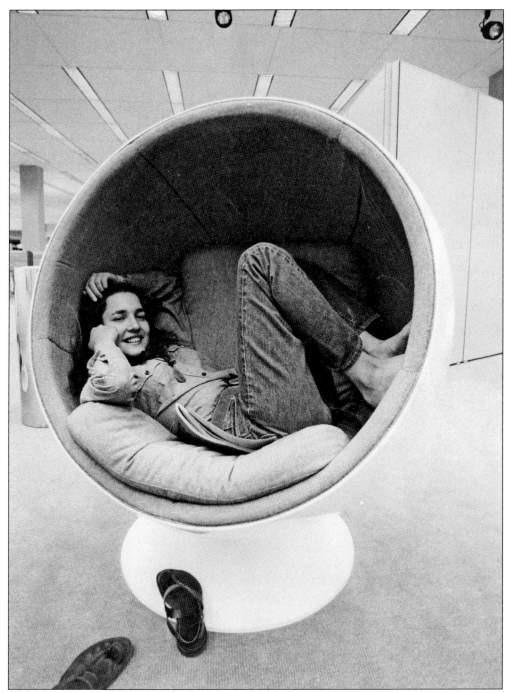

A DU student relaxes in an egg chair in Penrose Library shortly after it opened. Penrose Library was named after Spencer Penrose, who was born in 1865 in Philadelphia. In 1892, he came to Colorado and took part in the Cripple Creek gold rush. He founded the Utah Copper Company, which eventually became Kennecott Copper. In 1937, Spencer and his wife set up the El Pomar Foundation, which activated upon his death in 1939. The foundation donated $4.5 million toward the construction of Penrose Library in 1972.

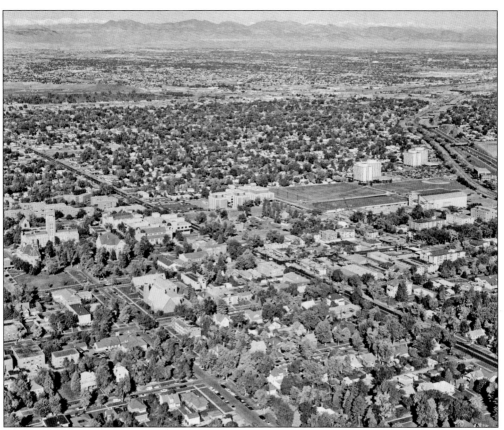

A 1973 aerial of the DU campus shows the new Penrose Library visible near the center of the photograph to the north of Mary Reed Building.

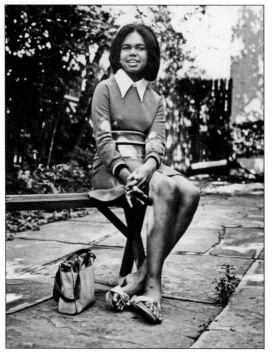

Future secretary of state Condoleezza Rice poses in her backyard in University Park in this photograph from the early 1970s. Rice was born in 1954 in Birmingham, Alabama. Her father was a Presbyterian minister who came to DU as a vice chancellor in 1967. Condi graduated from high school at St. Mary's Academy in Cherry Hills Village in 1970. She then attended DU, where she graduated in 1974. After earning a master of arts at Notre Dame, she returned to DU for her Ph.D. in international studies with a specialization on the Soviet Union. She graduated in 1981 at the age of 26.

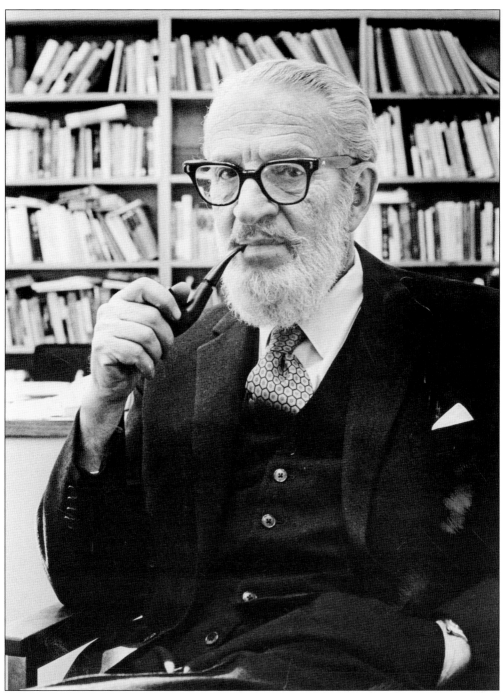

Dr. Josef Korbel was born in Czechoslovakia in 1909 and came to DU in 1949 to teach international studies after having been a United Nations diplomat. He is perhaps best known as the father of President Clinton's secretary of state Madeleine Albright and as a mentor of Condoleezza Rice, Pres. George W. Bush's secretary of state. He later became dean of the Graduate School of International Studies at DU. Korbel died in 1977. In May 2008, the name of the Graduate School of International Studies at DU was changed to the Korbel School of International Studies.

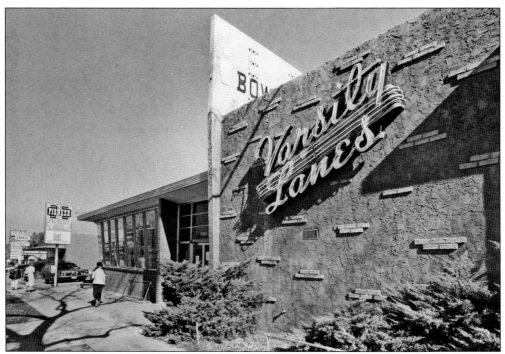

A 1980 photograph shows Varsity Lanes, located at 2040 South University Boulevard. Varsity Lanes was a popular bowling alley for DU students for many years. It was purchased by the university in 1958 and closed in the early 1980s. Plans to convert the site into the DU bookstore or a nightclub failed to materialize, and after standing vacant for several years, the site became a Walgreen's pharmacy. Today the site houses a bank.

DU students rock out in a Centennial Towers residence hall jam session in January 1981. The residence hall had been named in honor of the DU centennial in 1964 and was one of two twin residence halls, the other being Centennial Halls.

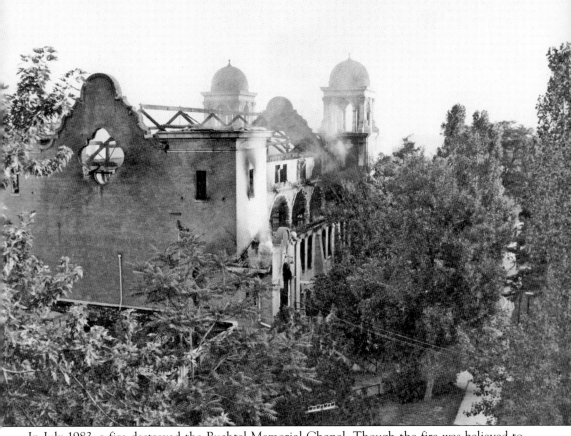

In July 1983, a fire destroyed the Buchtel Memorial Chapel. Though the fire was believed to have been the result of an arsonist, no one was ever convicted of the crime. A large percentage of the center of the building was made of wood, which allowed the fire to spread much faster than it normally would have. Today only the northeast tower remains and is now referred to as the Buchtel Memorial Tower.

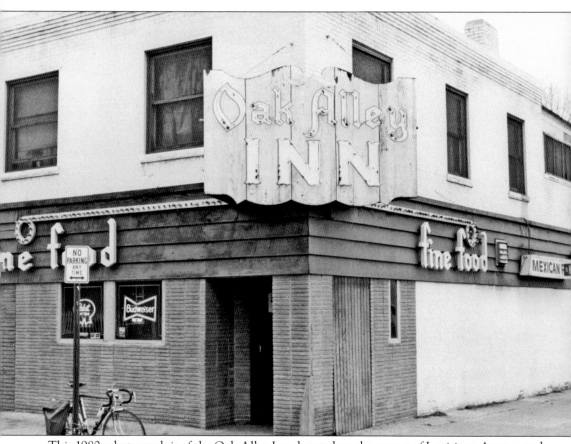

This 1980s photograph is of the Oak Alley Inn, located on the corner of Louisiana Avenue and South Pearl Street. For many years, the Oak Alley was a popular dining spot of the residents of South Denver. It was later replaced by the Margarita Bay Club, which later became Hanson's Grill and Tavern in 2002. (Courtesy the *Washington Park Profile*.)

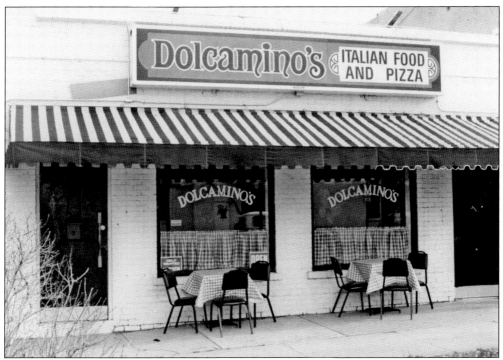

The popular DU area Italian eatery Dolcamino's opened in 1944 and thrived for 50 years at 2076 South University Boulevard near the corner of Evans Avenue and South University. It was then replaced by Coos Bay Bistro. Coos Bay closed in 2005, and the building was demolished to make way for high-rise apartments. (Courtesy the *Washington Park Profile*.)

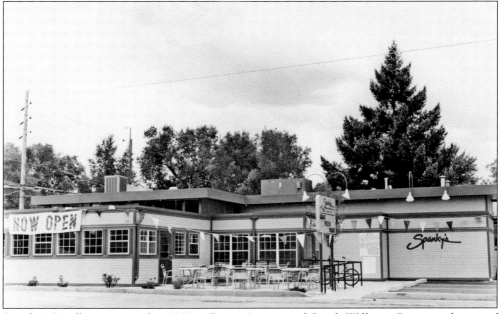

Spanky's Roadhouse opened in 1983 at Evans Avenue and South Williams Street on the site of a former gas station. Spanky's has been a popular hangout with the DU community ever since, well known for their hamburgers, shakes, and beers.

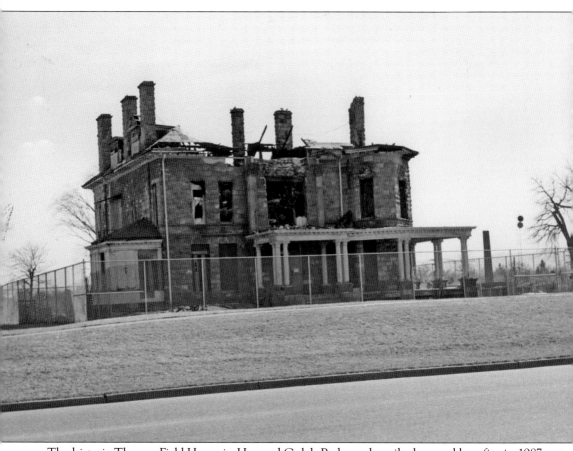

The historic Thomas Field House in Harvard Gulch Park was heavily damaged by a fire in 1987 and had to be demolished. (Courtesy the *Washington Park Profile*.)

Six

BUILDING BOOM AND THE NEW MILLENIUM

The University of Denver suffered through tough financial times throughout the 1980s. Several programs were cut, and excess property was sold off. In 1989, Daniel L. Ritchie became chancellor of the University of Denver and conditions began to change. Like Henry Buchtel in the early 20th century, Ritchie was a master fund-raiser. He served as chancellor from 1989 to 2005, a period during which the university saw the greatest building boom in its history. More than a dozen buildings were constructed during the Ritchie administration. The budget was balanced, and enrollment slowly but steadily grew.

The other major development in South Denver in the new millennium was the return of rail service, which had disappeared 50 years earlier with the growth of the automobile and bus. Denver slowly began installation of a major new light rail system, and a station came to Santa Fe Drive and Evans Avenue in 2005. This station was not really convenient for most South Denver residents as it was located too far to the west, but in 2007 a new station opened next to the University of Denver campus at South High Street and Buchtel Boulevard.

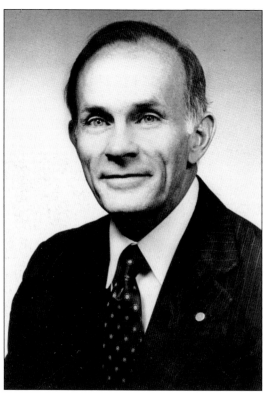

Before becoming chancellor of the University of Denver in 1990, Daniel L. Ritchie had served on the DU Board of Trustees for six years and had previously been CEO of Westinghouse Broadcasting.

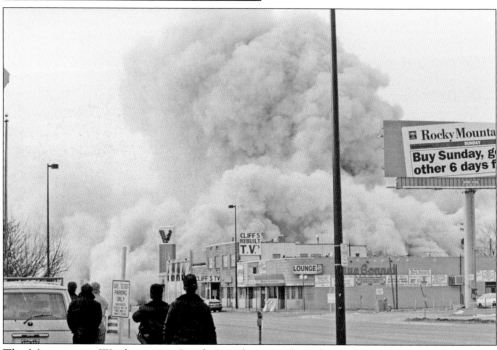

The Montgomery Ward store on South Broadway Boulevard was demolished on February 14, 1993, and replaced by the Broadway Marketplace, which featured a K-Mart, Office Max, and Albertson's grocery store. (Courtesy the *Washington Park Profile*.)

The University Hills Mall closed in 1996 and was demolished a short time later. It was replaced in 1997 with 16 retail spaces surrounding the perimeter of the old mall site, anchored by a King Soopers grocery store. (Courtesy the *Washington Park Profile*.)

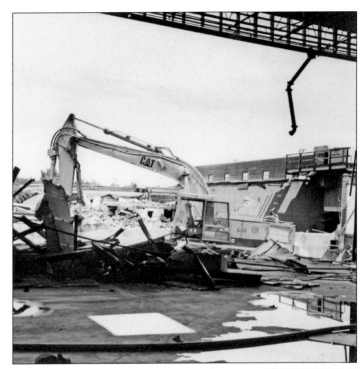

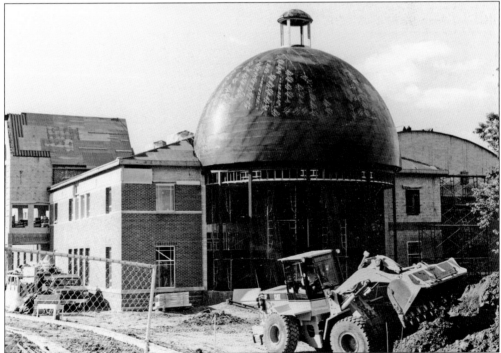

DU's Olin Hall, built in 1997 with funds given by the Olin Foundation, was the first of a number of buildings constructed during the chancellorship of Dan Ritchie. One of his stated objectives was to construct buildings that were designed to last hundreds of years, unlike many of the older structures at DU.

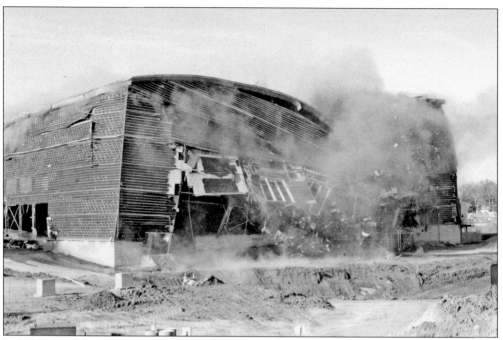

In 1998, the old DU Arena Fieldhouse was demolished to make way for construction of the new Ritchie Center on the same site.

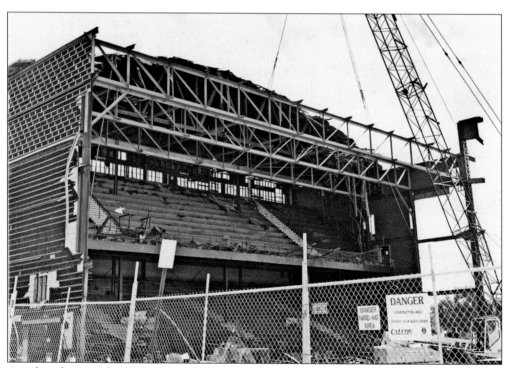

Another photograph of the Arena Fieldhouse demolition shows the old student bleacher section. (Courtesy the *Washington Park Profile*.)

In 1998, ground was broken for the Daniel L. Ritchie Center for Sports and Wellness, more commonly known as the Ritchie Center. The building was designed by DU architect Cab Childress and named for DU chancellor Dan Ritchie. Ritchie donated $15 million of his own funds to the project. Eventually DU would raise $450 million for campus improvements.

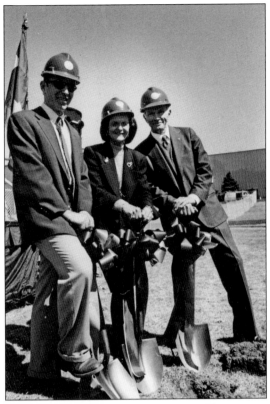

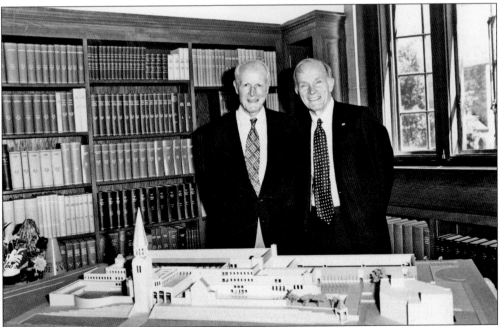

In this 1998 photograph, Bill Coors (left) and Dan Ritchie pose in front of a model of the Daniel L. Ritchie Center for Sports and Wellness. The Coors family donated funds to build a fitness center that bears their name inside the Ritchie Center.

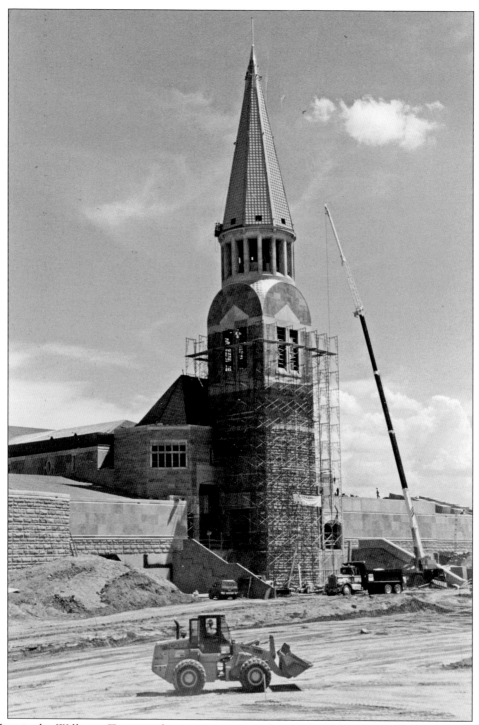

Here is the Williams Tower under construction at the Ritchie Center in 1999. The 215-foot Williams Tower at the Ritchie Center was designed by university architect Cab Childress, based on the southwest tower of Chartres Cathedral in France. It contains a 65-bell carillon directly under a golden spire. The bells were manufactured in the Netherlands.

120

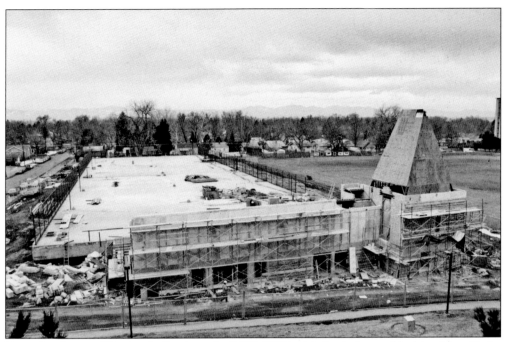

Named in honor of Benjamin Stapleton Jr. (1919–1992) with funds donated by his widow, Katie, the Stapleton Tennis Pavilion was completed in 1998 at a cost of $2.2 million. Ben Jr. was the son of the famous Denver mayor Stapleton.

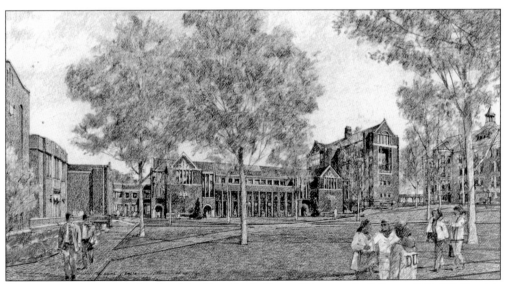

Here is an architectural sketch of the Daniels College of Business Building at DU. Bill Daniels (1920–2000) was known as the father of cable television. He endowed a business ethics program at DU, and the School of Business in turn was renamed the Daniels College of Business. The 110,000-square-foot building on the DU campus that bears his name opened in 1999, costing $25 million to complete. Though it was constructed just to the north of the oldest building on campus, University Hall, it was designed to blend in well with that structure.

The completed Daniels College of Business Building is pictured here in 2000.

The Cable Center Building on the north side of the DU campus was completed in 2001. Originally known as the National Cable Television Center and Museum, the name of the organization and the building was changed to the Alan Gerry Cable Telecommunications Center Building. Though it is located on the University of Denver campus, the Cable Center is independent of DU.

The Newman Center for the Performing Arts is named for Robert and Judi Newman, who donated an undisclosed sum toward its construction. The 181,298-square-foot facility was designed by DU architect Cab Childress and opened in 2002. It houses the Lamont School of Music and several public performance spaces. Robert Newman is a cofounder of J. D. Edwards.

The new Ricketson Law Building, a "green" structure, was completed on the DU campus in 2003. It has 242,000 square feet of space and cost $63 million to complete. The DU Law School had been located at the old Colorado Women's College campus at Montview Boulevard and Quebec Street since the 1980s, when it had moved there from downtown Denver.

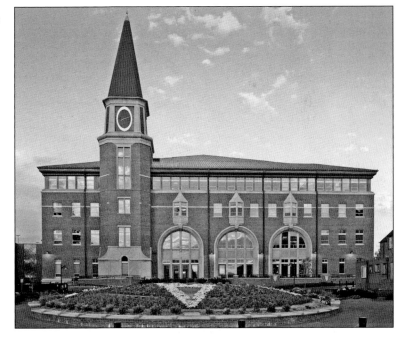

In 2004, the new Merle Catherine Chambers Center for the Advancement of Women opened at the corner of South High Street and Asbury Avenue. The 32,000-square-foot facility houses the Women's College of the University of Denver and the Women's Foundation of Colorado. It cost $8.9 million to complete.

In 2004, the DU hockey team won the first of back-to-back NCAA national championships. Prior to the 2004 and 2005 teams, DU had won five previous national hockey titles but had not won one in over 25 years.

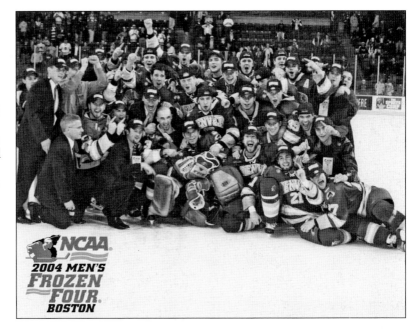

The 2006 Hotel Restaurant and Tourism Management Building at DU houses a multipurpose conference center, a full production kitchen, a 120-seat dining hall, and a Tuscan-style wine cellar.

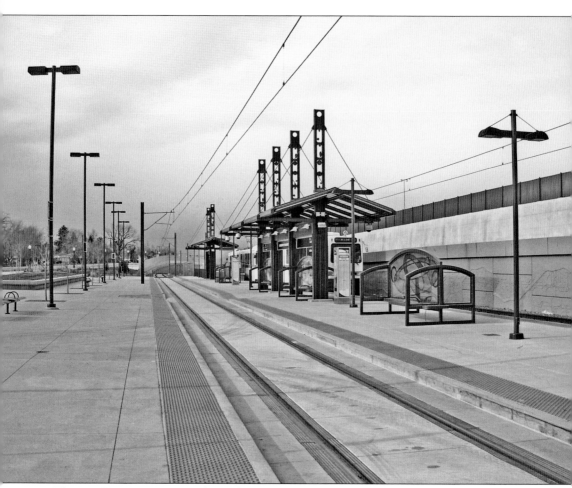

The new University RTD Light Rail Station is seen here shortly after opening in October 2007. Several apartment complexes were demolished in 2006 to make way for the new station, at South High Street and Buchtel Boulevard. Public rail service, which had been phased out of University Park and South Denver after World War II and replaced by buses, had returned in 2005 with the extension of the southeast Regional Transit Development (RTD) line to Evans Avenue, just west of Broadway Boulevard. (Courtesy the *Washington Park Profile*.)

BIBLIOGRAPHY

Bretz, James. *The Mansions of Denver: The Vintage Years 1870–1938.* Boulder, CO: Pruett Publishing Company, 2005.

Davis, Sally, and Betty Baldwin. *Denver Dwellings and Descendants.* Denver: Sage Books, 1963.

Denver Foundation for Architecture. *Guide to Denver Architecture with Regional Highlights.* Englewood, CO: Westcliffe Publishers, 2001.

Engle, Morey. *Denver Comes of Age.* Boulder, CO: Johnson Books, 1994.

Engle, Morey, and Bernard Kelly. *Denver's Man with a Camera: The Photographs of Harry Rhoads.* Evergreen, CO: Cordillera Press, 1989.

Etter, Don D. *University Park, Denver: Four Walking Tours 1886–1910, an Introduction to the Cultural Heritage of a Denver Community.* Denver: Graphic Impressions, 1974.

Goodstein, Phil. *Denver Streets.* Denver: New Social Publications, 1994.

———. *The History of South Denver, The Spirits of South Broadway.* Denver: New Social Publications, 2008.

———. *From Soup Lines to the Front Lines Denver During the Depression and World War II 1927–1947.* Denver: New Social Publications, 2007.

Noel, Thomas J. *Denver Landmarks and Historic Districts: A Pictorial Guide.* Niwot, CO: University Press of Colorado, 1996.

———. *Buildings of Colorado.* New York: Oxford University Press, 1997.

Noel, T., and B. Norgren. *Denver the City Beautiful and Its Architects, 1893–1941.* Denver: Historic Denver, Inc., 1987.

Norland, Jim. *The Summit of a Century: A Pictorial History of the University of Denver.* Centennial Publications, 1963.

Wood, Richard E. *Here Lies Colorado: Fascinating Figures in Colorado History.* Helena, MT: Farcountry Press, 2005.

Wyke, Millie Van. *The Town of South Denver.* Boulder, CO: Pruett Publishing Company, 1991.

DISCOVER THOUSANDS OF LOCAL HISTORY BOOKS
FEATURING MILLIONS OF VINTAGE IMAGES

Arcadia Publishing, the leading local history publisher in the United States, is committed to making history accessible and meaningful through publishing books that celebrate and preserve the heritage of America's people and places.

Find more books like this at
www.arcadiapublishing.com

Search for your hometown history, your old stomping grounds, and even your favorite sports team.

Consistent with our mission to preserve history on a local level, this book was printed in South Carolina on American-made paper and manufactured entirely in the United States. Products carrying the accredited Forest Stewardship Council (FSC) label are printed on 100 percent FSC-certified paper.

MADE IN THE
USA